JOHN SINGER SARGENT

Painting
Friends

With an essay by
Barbara Dayer Gallati

National Portrait Gallery, London

First published in the United States of America in 2015 by
Skira Rizzoli Publications, Inc.
300 Park Avenue South
New York, NY 10010
www.rizzoliusa.com

Originally published in Great Britain in 2015 by
National Portrait Gallery Publications,
St Martin's Place, London WC2H 0HE

Every purchase supports the National Portrait Gallery,
London. For a complete catalogue of current publications,
please write to the National Portrait Gallery at the address
above, or visit our website at www.npg.org.uk/publications

Copyright © 2015 National Portrait Gallery, London

Texts in the Portraits section are based on catalogue entries
in *Sargent: Portraits of Artists and Friends* by Richard Ormond
with Elaine Kilmurray, published in the United States of
America in 2015 by Skira Rizzoli Publications, and in Great
Britain in 2015 by National Portrait Gallery Publications

'John Singer Sargent's International Network of Artists
and Muses' copyright © 2015 Barbara Dayer Gallati

The moral rights of the author have been asserted. All rights
reserved. No part of this publication may be reproduced,
stored in a retrieval system or transmitted in any form
or by any means, whether electronic or mechanical,
including photocopying, recording or otherwise, without
the prior permission in writing of the publisher.

Library of Congress Control Number: 2014953445

ISBN 978-0-8478-4528-6

10 9 8 7 6 5 4 3 2 1

Printed and bound in Italy

Managing Editor Christopher Tinker
Senior Editor Sarah Ruddick
Picture research Kathleen Bloomfield
Production Manager Ruth Müller-Wirth
Design Turnbull Grey

p.14: *Claude Monet, Painting, by the Edge of a
Wood, c.1885* (detail of no. 12)

FSC
www.fsc.org

MIX
Paper from
responsible sources
FSC® C015829

Contents

John Singer Sargent's International Network of Artists and Muses

Barbara Dayer Gallati

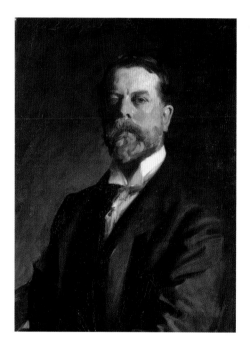

Fig. 1 *Self-Portrait*, 1907

John Singer Sargent (1856–1925) made international news in 1906 when he was invited to contribute a work to the celebrated collection of artists' self-portraits in the Uffizi Gallery in Florence, Italy. The request from the Uffizi was a rare honour and reveals the extent to which the realities of Sargent's art and life defy efforts to categorise his art according to national borders. The painting that Sargent deposited with the Uffizi in 1907 (fig. 1) embodies the hybrid nature of his cultural identity. The Uffizi authorities considered Sargent to be British, for his was one of three invitations for self-portraits issued to British artists in 1906 (the others were William Holman Hunt and Philip Wilson Steer), yet American newspaper reports trumpeted that Sargent was only the second American artist to be assumed into the Uffizi's pantheon of artistic achievement (George Peter Alexander Healy was the first). As if to blur intentionally the matters of nationality attached to his public persona, Sargent portrayed himself wearing the French Légion d'honneur ribbon, thus advertising his strong cultural connections with France. An important but seldom noted fact at the time was that Sargent's inclusion in the Uffizi's renowned collection of self-portraits virtually brought him home to his native city.

Indeed, Sargent was born in Florence in 1856, the first son of expatriate American parents, the physician Fitzwilliam Sargent and the former Mary Newbold Singer, who had moved to Italy in 1854. The Sargents' restless movements across Europe produced a relatively solitary, emotionally self-sufficient son, whose childhood was spent

largely in the company of his younger sister, Emily. Although without benefit of conventional schooling, Sargent acquired a broad education grounded especially in the visual wonders of European art and architecture that nourished his early appetite for drawing.[1] Throughout his boyhood, Sargent was encouraged by his parents to pursue his interest in art, yet their incessant peregrinations permitted no systematic training until the autumn of 1873, when he enrolled in the Accademia di Belle Arti in Florence, which he found profoundly unsatisfying.

In the spring of 1874 the Sargent family went to Paris, bent on selecting an instructor from whom the eighteen-year-old Sargent might gain serious art training. The artist of choice was the flamboyant, talented and sometimes controversial Charles Auguste Émile Durant, known as Carolus-Duran. Popular with American and British students because of his liberal teaching methods, Carolus-Duran espoused a direct painting technique that paid homage to the Spanish baroque master Diego Rodríguez de Silva y Velázquez, an artist who was much admired by Sargent as well. Carolus-Duran comfortably straddled the aesthetic gulf between the progressives and academics (he was a friend of Édouard Manet and Claude Monet, and a regular Salon exhibitor), and was then well on his way to becoming the pre-eminent French portraitist of his generation.[2] In a sense, Carolus-Duran, and by extension Velázquez, merged the concepts of artist and muse, operating for Sargent as salient factors in forming the complex dynamic of mind, eye and hand that is now associated with his art. Although the literature devoted to Sargent's very public career is voluminous, additional insight into the mind of Sargent may be gained by considering the labyrinthine, international matrix of artists, musicians (he was a talented pianist himself), writers, actors and patrons who were his friends and muses.

Sargent's years of study in Carolus-Duran's atelier in the company of many American-born artist hopefuls laid the foundation for his strong ties with North American art culture. And, although his status as his master's favourite might have triggered jealousy, his reputation within the colony of American students in Paris bred admiration. One of them, Julian Alden Weir, reported in a letter to his mother:

> I met this last week a young Mr. Sargent … one of the most talented fellows I have ever come across; his drawings are like the old masters, and his color is equally fine … He speaks as well in French, German, Italian as he does in English, has a fine ear for music, etc. Such men wake one up, and, as his principles are equal to his talents, I hope to have his friendship.[3]

Another important alliance was with J. Carroll Beckwith, with whom Sargent shared a studio beginning in August 1875.[4] From the start of their lifelong relationship Beckwith wistfully watched his friend's meteoric rise from the sidelines, as Sargent passed the rigorous *concours de places* (competitive examination) on his first try, thereby gaining admission to the prestigious École nationale supérieure des beaux-arts in Paris, while Beckwith failed to advance. Sargent's portrait of the magnetic Carolus-Duran (no. 1) functioned as an international ambassador attesting to his prodigious talent; it was exhibited at the 1879 Paris Salon, displayed in New York and Boston in 1880, and in London in 1882, thus broadcasting the young artist's remarkable ability and aesthetic pedigree. Moreover, Sargent was, by virtue of his language skills and European upbringing, able to form friendships outside the Anglo-American fraternity. One such relationship yielded a series of staggeringly brilliant portraits painted for the family of the playwright Édouard Pailleron, one of the earliest of Sargent's French patrons. Sargent's portrait of Marie Pailleron (no. 4), shown at the Salon of 1880, attracted significant critical attention and did as much as the portrait of Carolus-Duran to advertise not only Sargent's growing stature as a young artist to be watched but also his connections with a network of France's cultural luminaries. The combination of wealth, glamour and intellectual prowess possessed by the Paillerons heightened Sargent's desirability as a painter of fashionable, daringly innovative portraits.

Sargent's circle of French acquaintances was varied. He may have met Claude Monet in 1876; by the 1880s the two had established an especially warm rapport, occasionally working side by side *en plein air* and exchanging letters and visits over several decades. At the opposite end of the aesthetic spectrum was the young artist's affiliation with a number of Aesthetes, many of whom – including Oscar Wilde and the novelist Paul Bourget – gathered at the salon of the American expatriate Henrietta Reubell. Chief among these apostles of refined decadence was Count Robert de Montesquiou, whom Sargent described as 'unique and extra-human'.[5] Also significant was Sargent's friendship with the novelist, poet, orientalist and critic Judith Gautier (no. 10), with whom he shared an abiding passion for the music of the German composer Richard Wagner. Sargent's fascination with the sophisticated and intellectually gifted Gautier manifested itself in a number of portraits he painted of her in the mid-1880s, and it is perhaps telling that Gautier was one of the few critics to comprehend the 'visionary beauty' of Sargent's *Madame X (Madame Pierre Gautreau)* (fig. 2) when it was shown at the 1884 Paris Salon.[6] On the whole,

however, the portrait produced such spectacularly disastrous critical reactions that the young artist eventually quit Paris for more welcoming artistic climes.

Of course, Sargent had never been completely anchored in Paris. He made his first trip to the United States in 1876 and also spent considerable time in Italy, Spain and London, as well as shorter stays elsewhere in the years leading up to the *Madame X* debacle. Even before that crushing disappointment, however, Sargent had been making inroads into the London art world, exhibiting at the Royal Academy, the Grosvenor Gallery and the Fine Art Society. In March 1884 he attended the retrospective exhibition of Sir Joshua Reynolds' work, held at the Grosvenor Gallery, with the novelist and critic Henry James, whom he had met in Paris that February. In the ensuing months, Sargent entered the orbit of a new group of artists and writers, mainly through James's agency, among them the American artist Edwin Austin Abbey, who was instrumental in introducing Sargent to the idyllic Broadway colony of artists and writers in 1885.[7]

Located in rural Worcestershire, Broadway exuded an old-world atmosphere, untouched by modernity. The village had so charmed the American artist Frank Millet and his wife Lily (no. 16) that they rented Farnham House in 1885 and then Russell House in 1886, which respectively became the nucleus of a shifting group of visitors, made more numerous over the summer seasons. Apart from the Millets and their family, Abbey was a relatively permanent presence. Also among the regulars were James and the writer Edmund Gosse (no. 17), with Lawrence Alma-Tadema, Alfred Parsons and Frederick Barnard making up the contingent of painters in more-than-occasional residence. Others, such as the American artists J. Appleton Brown, Candace Wheeler and her daughter Dora and Edwin Howland Blashfield, were there less frequently.

Sargent, too, fell under the spell of Broadway, finding it a welcome respite from professional pressures, enjoying sympathetic company and new-found freedom for artistic experimentation. His Broadway interludes yielded some of his most intense investigations of Impressionism, a highpoint of which is *Carnation, Lily, Lily, Rose* (no. 15), a work that gained substantial critical and popular acclaim when it was shown at the Royal Academy of Arts in London in 1887. Painted in the out-of-doors over two seasons in increments of mere minutes required to capture a specific twilight effect, it depicts the daughters of Frederick

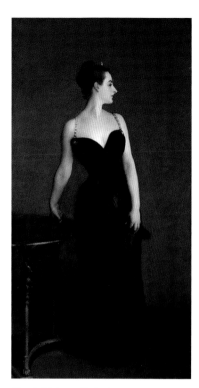

Fig. 2 *Madame X (Madame Pierre Gautreau)*, 1884

Barnard lighting Japanese lanterns in the garden of Russell House. With these child muses, Sargent created an image replete with poetic innocence sufficient enough to counteract the tarnish of the demi-monde as wrought by his more dangerous muse, Madame X.

From the time of their first meeting, Henry James had waged a rigorous campaign to convince Sargent of the value of moving permanently to London. Although the artist had ostensibly set up residence in London by 1886, it was not until June 1887 that he can be said to have committed himself to life in Britain's art capital, with the signing of a three-year lease for his studio in Tite Street, Chelsea. The Chelsea neighbourhood was an artistic hub, whose residents included the artists James Abbott McNeill Whistler, George Percy Jacomb-Hood, William Rothenstein and Philip Wilson Steer, as well as the writers Oscar Wilde and George Meredith, most of whom, like Sargent, frequented the Chelsea Arts Club.

In addition to exhibiting at the Royal Academy, Sargent started showing his paintings at the New Gallery and the New English Art Club, an organisation founded in 1886 in support of artists aligned with progressive styles imported primarily from France. His exhibition patterns – that is, Sargent's decisions of which paintings to show where and when – seem calculated as if to declare his intention to create a rare breed of portraiture, accomplished mainly by portraying well-known artistic personalities drawn from his wide array of friendships: for instance, *Ellen Terry as Lady Macbeth* (no. 23) (at the New Gallery in 1889), *George Henschel* (no. 21) (at the Academy in 1889) and *An Out-of-Doors Study*, a portrait of the French artist Paul Helleu and his wife Alice (no. 20) (at the New English Art Club in 1892). The dramatic full-length portrait of Terry galvanised the critics, many of whom focused on the actress's richly decorated gown designed by another of Sargent's friends, Alice (Strettell) Comyns Carr, whose husband Joseph Comyns Carr – an art critic, playwright and theatre manager – was also the founder of the New Gallery. Similarly intricate webs of interpersonal connections form the contexts for most of Sargent's portraits of his close friends. In the case of the musician George Henschel, Sargent had met him through one of his first English patrons, music-lover Robert Harrison, to whom Sargent had been introduced by Alma Strettell (Alice Comyns Carr's sister), a fellow denizen of the Broadway colony, whose friendship with Sargent had come about through Henry James. As for *An Out-of-Doors Study*, the painting aligned Sargent with modern French techniques by portraying his fellow artist Helleu in the act of painting *en plein air* in the English

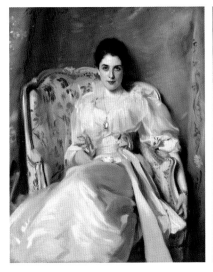

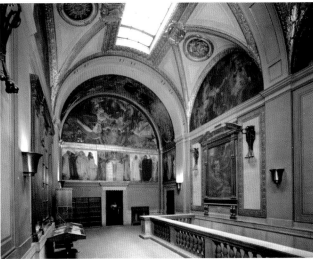

countryside, subtly underscoring the fact that Impressionism had truly arrived in Britain.

The judicious selection and timing for the display of the uncommissioned portraits noted here suggest that Sargent determinedly meant to link his public reputation with stellar figures in the arts at a time when he was still having difficulty obtaining society portrait commissions. However, after the critical triumphs of *Mrs Hugh Hammersley* at the New Gallery and *Lady Agnew of Lochnaw* (fig. 3) at the Royal Academy in 1893, Sargent was firmly on the path to becoming London's most sought-after society portraitist. Nevertheless, he continued to paint and display portraits of members of his intimate circle, and, despite a relentless schedule, he also found the time to satisfy his passions for the theatre and music, especially devoting himself to promoting the careers of the composers Gabriel Fauré and Léon Delafosse. Fauré reportedly composed pieces for the fashionable amateur singer Mabel Batten, Sargent's extraordinary portrait of whom conveys the capacity of music to transport maker and listener to another realm of consciousness and embodies Sargent's empathy with that experience (no. 24).

As was his wont, Sargent would divide each year into periods of travel, including extended stays in the United States, where his activity there alone would have been a sufficient match for any other artist's lifetime of accomplishments. It was a commission from the powerful New York financier Henry G.

Fig. 3 (above left) *Lady Agnew of Lochnaw*, 1892

Fig. 4 (above) *Triumph of Religion* mural at the Museum of Fine Arts, Boston

Fig. 5 *Isabella Stewart Gardner*, 1888

Marquand (possibly instigated by Alma-Tadema) that precipitated Sargent's first working trip to the United States in the early autumn of 1887 (he would remain until May 1888). Over the decade prior to that, however, he had steadily established a public profile in North America, primarily through exhibiting his paintings in New York at the Society of American Artists and the National Academy of Design. Then, too, he had numerous friends, colleagues and patrons ready to welcome him. This initial excursion into the North American market set the template for Sargent's subsequent trips inasmuch as New York and especially Boston were to remain central to the artist's professional and social life outside of Britain. To be sure, Sargent would spend more time in Boston over the years as he devoted himself to the challenges presented by the mural commissions for the Boston Public Library, the Museum of Fine Arts, Boston (fig. 4), and the Widener Memorial Library at Harvard University.

In Boston, Sargent reunited with his friend the lawyer and watercolourist Edward Darley Boit, whose daughters he had painted in the family's Paris apartment. On this trip Sargent would paint Boit's wife, Mary Louisa, as well as the formidable collector Isabella Stewart ('Mrs Jack') Gardner, to whom he had been introduced by both his Boston cousin Ralph Curtis and Henry James in London and who would become one of his most ardent patrons. Sargent's portrait of 'Mrs Jack' (fig. 5) was as unconventional as its sitter and commanded the attention of throngs of visitors who attended the artist's first one-man exhibition, which opened in 1888 at Boston's St Botolph Club. Significant, too, was the banker Charles Fairchild. It was Fairchild who had commissioned a portrait of the author Robert Louis Stevenson (Taft Museum of Art, Cincinnati, Ohio) from Sargent earlier that year as a gift for his wife, a prominent figure in Boston's literary circles. The bond between the Fairchild family and Sargent would endure for decades, with Charles acting as the artist's financial advisor. Through these friends and others, Sargent entered the guarded precincts of Boston's elite.

New York City was also the scene of reunions for Sargent, who rekindled his friendships with the sculptor Augustus Saint-Gaudens, Stanford White (of the architectural firm McKim, Mead & White) and Beckwith. The talented, gregarious and high-living White was a pivotal figure in Sargent's life, having offered the artist the Boston Public Library mural commission, which occupied him from 1890 to 1919. It was likely White who suggested that

Sargent paint the portrait of the celebrated actor Edwin Booth for The Players Club in New York, a commission that led Booth to call upon Sargent for portraits of fellow actors Lawrence Barrett and Joseph Jefferson.

Of the portraits of performers Sargent would paint in the United States, perhaps none matched that of La Carmencita (no. 28), in which major elements of Sargent's personal life and tastes converge. Ever captivated by things Spanish, Sargent pronounced the sultry singer–dancer Carmen Dauset a 'bewilderingly superb creature', having recently witnessed her in spirited performance at Koster & Bial's Music Hall in New York City. He had done so in the company of Carroll Beckwith, who soon hosted a private party at his studio featuring the dancer.[8] The unalloyed exoticism of La Carmencita (Dauset's stage name) exerted its strange appeal on Sargent, who pressed her into sitting for him and borrowed the painter William Merritt Chase's large studio to stage an evening similar to Beckwith's with Isabella Gardner in attendance.[9] The largest of several portraits of La Carmencita painted by Sargent, the dramatic full-length canvas drew sensational reviews when it was exhibited in New York, London and Paris, after which it was purchased by the French government in 1892.

Sargent was absorbed into officialdom in 1897 with his election to full academician at the Royal Academy, London, a distinction based mainly on his reputation as the foremost Anglo-American portraitist. In the first years of the new century, however, Sargent's enthusiasm for portraiture diminished to the extent that in 1907 he forswore taking further commissions, a resolution he kept with rare exceptions because of the demands placed on his time and energy in connection with his Boston mural projects. He turned, instead, to creating figure paintings and landscapes in oil and watercolour, most of which were executed during his travels in the company of close family members and others of their intimate circle. The products of this new direction, far from being merely leisure pursuits, demonstrate Sargent's continuing artistic development and capacity for invention. Watercolours such as *In the Generalife* (fig. 6) attest as well to persistent themes in his art. Painted in the gardens of the Generalife at the Alhambra in Granada, Spain, the watercolour portrays the artist's sister Emily at work on a painting of her own in the company of the American artist Jane de Glehn (a distant cousin of Henry James) and a Spanish friend, Dolores Carmona (on the right). As such, the image embraces the international nature of Sargent's friendships,

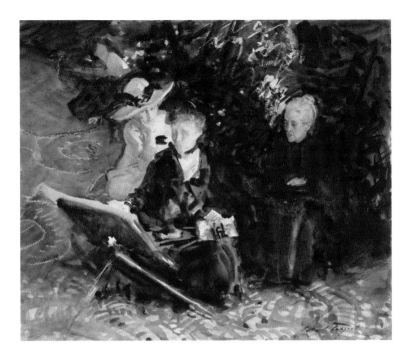

Fig. 6 *In the Generalife*, 1912

his identity as a portraitist, his *plein-air* practice and the tranquillity he experienced in an essentially foreign setting. Attending to the exigencies of the muse at hand, Sargent was, as his biographer Stanley Olson asserted, 'at home everywhere, and belonged nowhere'.[10]

1 In a letter to his mother in the United States, from Rossinière, Switzerland, 16 September 1861, Sargent's father reported, 'Johnny is well and is as fond as ever of drawing. I send you a drawing of a bunch of "Johnny-Jump-Ups," which he took from nature the other day.' Archives of American Art, F.W. Sargent Papers, reel D317, fr. 6.

2 For Carolus-Duran's teaching methods and American students, see H. Barbara Weinberg, *The Lure of Paris: Nineteenth-Century American Painters and Their French Teachers* (Abbeville Press, New York, 1991), pp.189–219.

3 Julian Alden Weir to his mother, Paris, October 4, 1874, quoted in Weinberg, ibid., p.207.

4 See Roberta J.M. Olson, 'John Singer Sargent and James Carroll Beckwith, Two Americans in Paris: A Trove of Their Unpublished Drawings', *Master Drawings,* Vol. XLIII, no. 4 (Winter 2005), pp.415–39, in which Beckwith's drawings of Sargent in their studio are reproduced.

5 Sargent's letter to Henry James introducing Montesquiou is quoted in Albert Boime, 'Sargent in Paris and London: A Portrait of the Artist as Dorian Gray', in Patricia Hills, ed., *John Singer Sargent* (Whitney Museum of American Art in association with Harry N. Abrams, New York, 1986), p.76.

6 Judith Gautier, *Le Rappel* (1 May 1884): p.1, quoted in Richard Ormond and
 Elaine Kilmurray, *John Singer Sargent: The Early Portraits, Complete Paintings,
 Volume I* (Yale University Press, New Haven and London, 1998), p.114.

7 For the Broadway colony, see Marc Alfred Simpson, 'Reconstructing
 the Golden Age: American Artists in Broadway, Worcestershire,
 1885 to 1889', Ph.D. diss., Yale University, 1993.

8 Undated letter [1890] from Sargent to Isabella Stewart Gardner, Isabella
 Stewart Gardner Museum, Boston, quoted in Richard Ormond and Elaine
 Kilmurray, *John Singer Sargent: Portraits of the 1890s: Complete Paintings
 Volume II* (Yale University Press, New Haven and London, 2002), p.21.

9 For La Carmencita's popularity in New York, see James Ramirez, *Carmencita:
 The Pearl of Seville* (Press of the Law and Trade, New York, 1890).

10 Stanley Olson, 'On the Question of Sargent's Nationality', in Patricia
 Hills, ed., *John Singer Sargent* (Whitney Museum of American Art
 in association with Harry N. Abrams, New York, 1986), p.17.

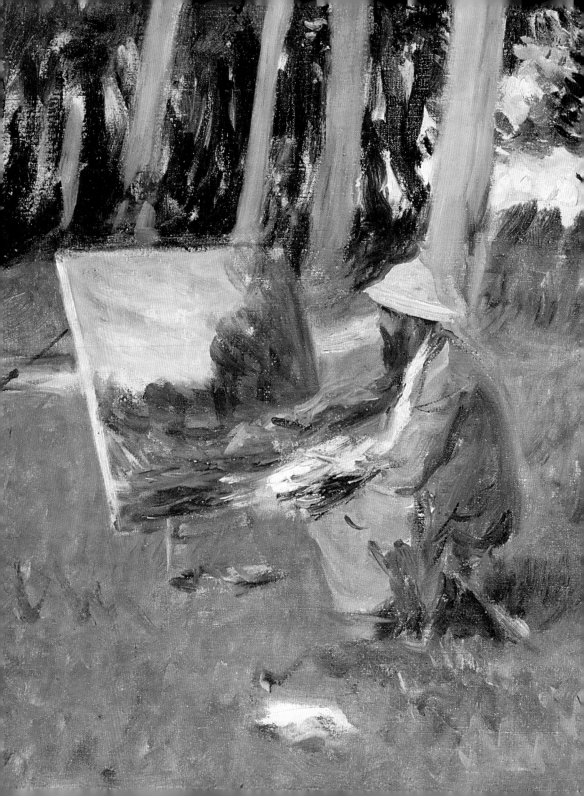

Portraits

1. *Carolus-Duran*

1879

Oil on canvas, 1168 x 960mm
Inscribed, upper right: *à mon cher maître M. Carolus Duran, son élève affectioné/John S. Sargent. 1879* ['to my dear master M. Carolus Duran, his affectionate pupil/John S. Sargent. 1879']
Sterling and Francine Clark Art Institute,
Williamstown, Massachusetts, USA

It would be difficult to overestimate the importance the role Sargent's portrait of his master Carolus-Duran (1837–1917) played in his career. Carolus-Duran was a celebrated figure in the world of Parisian art and theatre, known for his stylish society portraits and as something of a showman. The influential teacher's atelier, established in 1872, became a desirable alternative to the academic system. His approach was radical: he encouraged his students to draw and paint simultaneously, using a loaded brush. Carolus-Duran came, however, to be regarded with suspicion by progressives who considered that he had abandoned his principles to satisfy the market.

Sargent entered Carolus-Duran's atelier in 1874, a stellar pupil from the outset. In 1877, he was chosen to assist his mentor with a ceiling decoration for the Palais du Luxembourg, into which the artists incorporated portraits of each other. Thereafter, Carolus-Duran agreed to sit to Sargent, who sent his portrait to the Salon in 1879, where it received an honourable mention. His decision to paint and then exhibit a portrait of his master may have been strategic, but he could not have predicted that Carolus-Duran would be awarded the médaille d'honneur that year too. Sargent went on to make the most of Duran's celebrity and his own early success, exhibiting the portrait in New York and Boston (1880), London (1882) and Paris again (1883). His phenomenal success in Paris in the early 1880s and then in America and London in the later 1880s and 1890s meant that his reputation would eclipse that of Carolus-Duran.

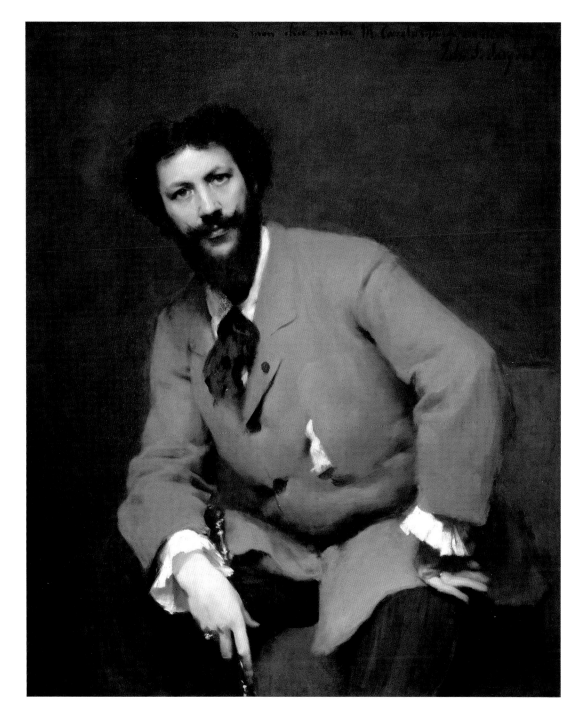

2. *Ramón Subercaseaux in a Gondola*
*c.*1880

Oil on canvas, 371 x 549mm
The Dixon Gallery and Gardens, Memphis, Tennessee, USA

By September 1880, Sargent was living in Venice and had
taken a studio in the Palazzo Rezzonico, Canal Grande. It
was an immense house, where several artists were installed,
including one of his Paris friends, Ramón Subercaseaux
(1854–1937). Chilean Consul in Paris since 1874,
Subercaseaux was also a writer and artist and an enthusiastic
observer of the art world. He was to spend September and
October in Venice with Sargent and his family, an autumn
in which the days were still long enough for them to make
the most of the beauties of the lagoon and the enchanting
islands. Subercaseaux was invited to work with a group of
artists, and the present sketch must have been painted on one
of their open-air expeditions. The gondola is in a narrow
side canal, and Subercaseaux is shown with a sketchbook
and a watercolour box on his lap, looking keenly at the
figure opposite, whom he can see, but the spectator cannot.
Subercaseaux's features are on the edge of caricature, and
the brushwork is brutal and chaotic with an exaggerated
sketchiness that is quasi-comic, a parody of the Impressionist
sketch. It is all a game, painted for someone, a fellow artist,
who is in on the joke. If Subercaseaux did paint a portrait
of Sargent, however, it is presently untraced. A sensitive
portrait of Subercaseaux by Sargent (*c.*1880, Saint Louis
Art Museum) might have been painted in Venice or in
Paris; his full-length portrait of Subercaseaux's wife Amalia
(no. 6) won him a medal in the Paris Salon in 1881.

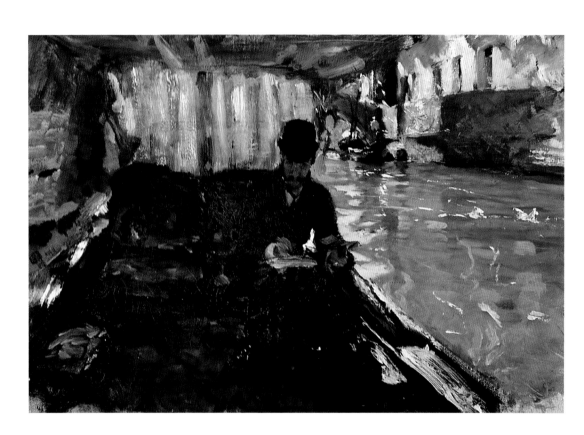

3. *Édouard Pailleron*
1879

Oil on canvas, 1385 x 960mm
Inscribed, lower left: *John S. Sargent*
Musée d'Orsay, Paris, France

The Paillerons were among Sargent's earliest French patrons.
The young artist probably owed the clutch of commissions
from the family to the success of his portrait of his master
Carolus-Duran at the Salon of 1879. Sargent chose to send
the portrait of Madame Pailleron, rather than that of her
husband, to the Salon in 1880, perhaps to make a decisive
contrast to the three-quarter-length male figure (of Carolus-
Duran) that he had exhibited the previous year and to indicate
his range as a portraitist. In the years after its completion,
although this portrait of Édouard Pailleron (1834–99) was not
exhibited in public, the image of Pailleron – the bohemian
writer, standing in a pose of studied informality, his attire on
the cusp of negligence, a dog-eared book in his hand – was
widely circulated. Pailleron was elected to the Académie
française in 1882, and, in a publicity coup, an engraving
of the portrait was reproduced on the front of the French
periodical *L'Illustration*. Art critic Jules Claretie wrote a piece
to accompany it, comparing the portrait to a Van Dyck and
linking it to Pailleron's election to the Académie. The portrait
itself was first seen in public in June 1893, when it was one
of a thousand works exhibited at the Galerie Georges Petit,
by and in aid of the Association des journalistes parisiens. It
hung alongside Édouard Manet's portrait of Émile Zola and
works by, among others, Carolus-Duran, Paul Baudry, Jean-
Jacques Henner, Henri Fantin-Latour and Raphaël Collin.

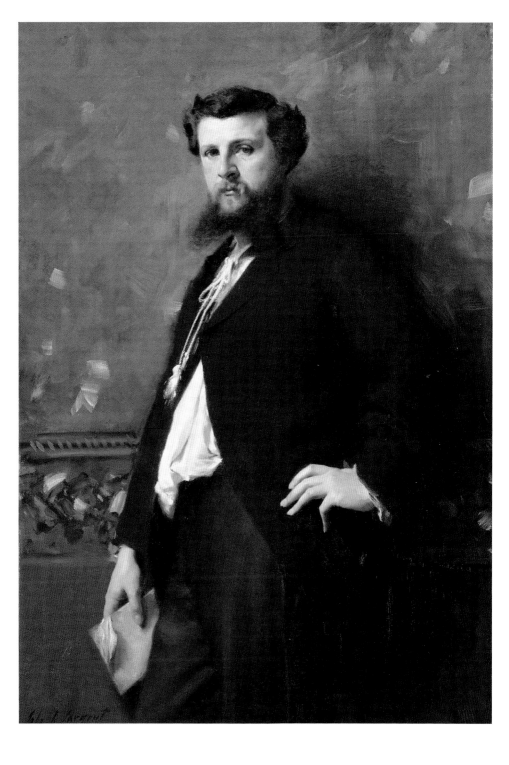

4. *Madame Édouard Pailleron*
1879

Oil on canvas, 2070 x 1007mm
Inscribed, lower right: *John S. Sargent/Ronjoux 1879*
Corcoran Gallery of Art, Washington, DC, USA

Madame Édouard (Marie) Pailleron (1840–1913) was the
daughter of François Buloz, a highly influential figure in
French cultural life. Buloz virtually reinvented the journal
Revue des deux mondes, was its editor for more than forty years
and attracted to it writers of the calibre of Charles-Augustin
Sainte-Beuve, Honoré de Balzac, Victor Hugo, Hippolyte
Taine and Ernest Renan. He was also chief administrator
(1838–48) of the Comédie-Française. In 1862, Marie Buloz
married a young playwright, Édouard Pailleron, and, by the
time this portrait was painted, his *comédies de moeurs* (comedy
of manners) had made him famous. The commission followed
on from Sargent's portrait of Pailleron himself and was painted
at the Paillerons' country seat at Ronjoux in the Haute-
Savoie. Sargent is painting a formal portrait, but, in placing
his sitter *en plein air*, he is signifying that this is portraiture in
the modern manner. He unites the narrow portrait format
with the landscape background dramatically, tipping up
the picture plane so that only a small slice of architectural
detail at the top anchors the composition in real space. The
silhouette of Madame Pailleron's fashionable black lace dress
with its froth of white petticoat is crisp against the crocus
and leaf-scattered sweep of grass behind her and ensures
that the portrait element takes precedence. The portrait was
exhibited at the Salon in 1880 with Sargent's ravishing tonal
study of white-on-white, *Fumée d'ambre gris* (The Clark
Art Institute, Williamstown, Massachusetts). A small panel
of Madame Pailleron was probably painted as a preparatory
study for the work shown here, as part of the artist's process.

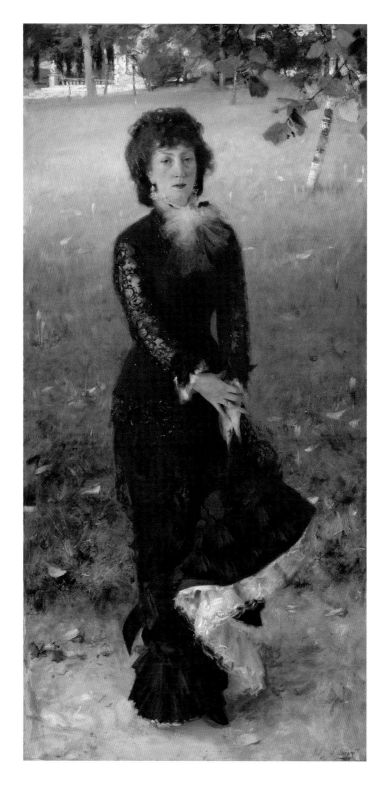

5. *Portraits de M.E.P. … et de Mlle L.P. (Portraits of Édouard and Marie-Louise Pailleron)*
1881

Oil on canvas, 1524 x 1753mm
Inscribed, upper right: *John S. Sargent*
Des Moines Art Center, Iowa, USA

This double portrait, Sargent's first, completes the Pailleron family group. The young Édouard (1865–?) has left no account, but Marie-Louise (1870–1951) became a literary figure in her own right as the historian of the *Revue des deux mondes* and author of many erudite published works. She was married to, and divorced from, the French writer and critic Paul Bourget. For the portrait, Marie-Louise recounts no less than eighty-three sittings, as well as battles about costume and the arrangement of her hair. The children are represented in a confined interior space, suggestive of a photographer's studio, and a sense of claustrophobia is enhanced by the insistently rich background tones. Marie-Louise is the focal point. Her brother, seated at an angle and on the far side of the sofa, seems a secondary presence. The children are dressed traditionally in black and white, but there are exotic references in the accessories: the Persian carpet and Marie-Louise's torque bracelet and brooch, a variant in miniature of the necklace worn by the model in *Fumée d'ambre gris* (Sterling and Francine Clark Art Institute, Williamstown, Massachusetts). The portrait was exhibited at the Salon in 1881. Contemporary critics were uneasy about the influence of Carolus-Duran, but, on the whole, commentators found the image charming. The psychological intensity, the knowingness of the children and the overall mood of ambiguity led a later art historian and museum director, Frederick Sweet, to liken the children to those portrayed in Henry James's ghost story *The Turn of the Screw* (1898); recent scholars have found it equally disquieting.

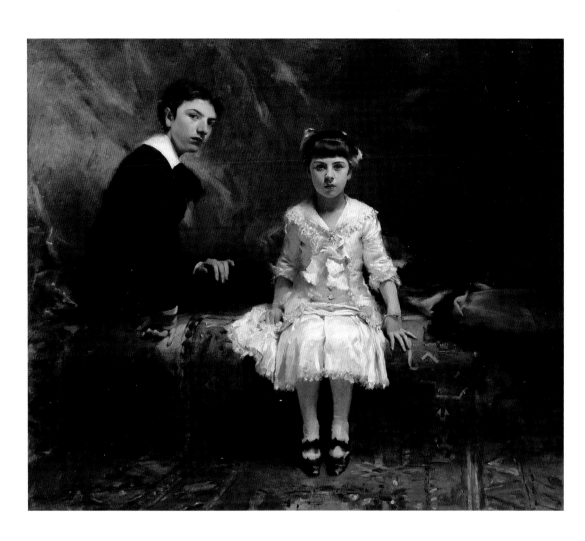

6. *Madame Ramón Subercaseaux*
1880

Oil on canvas, 1651 x 1099mm
Inscribed, lower right: *John S. Sargent*
Private Collection

A subtle expression of the collaboration between a young artist making his way in the Parisian art world and a young couple with progressive tastes, this portrait shows Sargent experimenting with contemporary ideas about portraiture. It depicts Amalia (1860–1930), the wife of the Chilean diplomat and artist Ramón Subercaseaux, seated at a piano in the couple's residence on the fashionable Avenue du Bois de Boulogne. Music played an important role in the portrait sittings; Madame Subercaseaux played for Sargent while he worked. The aesthetic setting, costume and accessories signify the sitter's style and social status; the apparent immediacy of her pose suggests a moment of private life. Sargent is working within an established portrait tradition yet assimilating evolving ideas about representation and identity.

The Subercaseaux visited the Salon in 1880 and were impressed by the sensibility of Sargent's white-on-white study, *Fumée d'ambre gris* (Sterling and Francine Clark Art Institute, Williamstown, Massachusetts); receptive to its whites and greys, to the concept of formal qualities as an organising principle in painting. In this portrait, the tonal range – apart from the dark mass of the piano and the black-and-red detail of the dress and accessories – is narrow and light. The composition's relatively flat and decorative surface and the modelling of the figure in relation to the background reveal Sargent's awareness of the contemporary enthusiasm for Japanese art. The portrait was important in Sargent's early career. Exhibited at the Salon in 1881, it earned him a second-class medal; thereby designated *hors concours*, he could exhibit at future Salons without submitting to the jury.

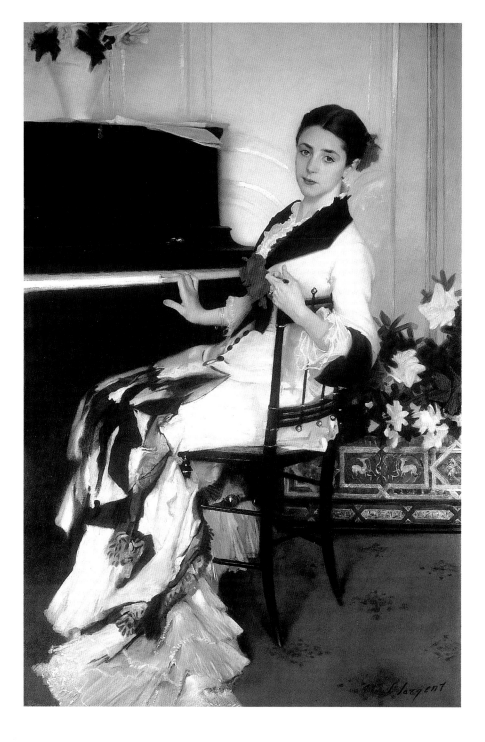

7. *Dr Pozzi at Home*
1881

Oil on canvas, 2016 x 1022mm
Inscribed, upper right: *John S. Sargent 1881*
The Armand Hammer Collection,
Hammer Museum, Los Angeles

Samuel-Jean Pozzi (1846–1918) was the father of modern French gynaecology; his practices advanced the reproductive safety and dignity of women. Surgeon to the Parisian beau monde, he counted among his friends such luminaries as the family of Marcel Proust, the celebrated *salonnière* Judith Gautier (no. 10) and Count Robert de Montesquiou. Glamorous and charismatic, Pozzi had many legendary affairs, including a long relationship with the actress Sarah Bernhardt. There was a sense of spectacle and danger about him: he performed operations for audiences and in private homes, and he founded the League of the Rose, a society devoted to the confession and acting out of sexual experiences. Carolus-Duran (no. 1) probably introduced Sargent to Pozzi, and the commission for the portrait may have come about as the result of the introduction. Sargent portrays this most worldly of men in quasi-ecclesiastical mode. The gracious and slightly mannered pose, the costume and palette reference old masterly images of popes and cardinals, such as Velázquez's *Pope Innocent X* (completed 1650, Galleria Doria Pamphilj, Rome). The composition reflects Pozzi's reputation as a sensualist and an aesthete. The symphony of reds is insistent and visceral (a gesture to the sensational aspects of his medical practices), but the flashiness is offset by the refinement of his finely drawn surgeon's hands, exquisitely pleated white shirt and delicately embroidered slippers. The portrait was the first work Sargent exhibited at the Royal Academy of Arts, London (in 1882); it was praised for its technique and daring, for its impudent splendour.

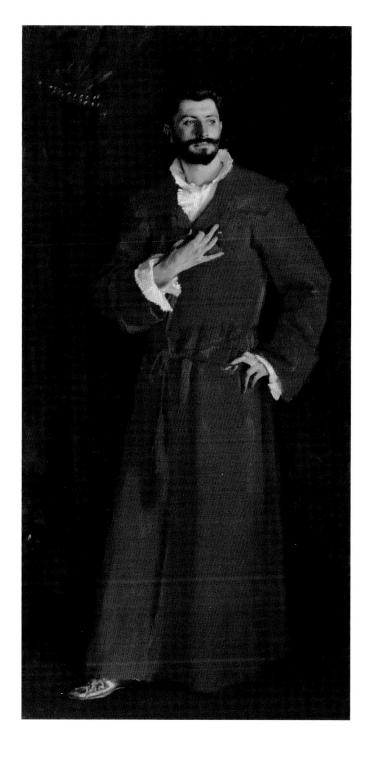

8. *Vernon Lee*
1881

Oil on canvas, 537 x 432mm
Inscribed and signed, upper right:
to my friend Violet / John S. Sargent
Tate, UK

Sargent used the end of his brush to write an inscription
through the wet paint to 'Violet' Paget; his childhood
friend was better known as Vernon Lee (1856–1935), the
pen name of a woman of letters, art historian, feminist and
pacifist: Vernon Lee's brilliance and intellectual reach were
formidable. An authority on the Italian Renaissance, her range
of published work included supernatural fiction, aesthetics,
psychology, literary criticism, novels and plays. Sargent
painted this sketch in a single session in June 1881, when
he was visiting London and Vernon Lee was staying with
her friends the Robinsons (he painted a portrait, now in a
private collection, of the poet, essayist and biographer Mary
Robinson during the same visit). Vernon Lee's pseudonym
and her way of dressing *à la garçonne* (in a boyish style)
encouraged a sense of ambiguity about her sexual identity
(she had romantic friendships with several women, among
them Mary Robinson). In this succinct study, painted in
about three hours' sitting, Sargent depicts her in the severely
tailored black silk dress with high starched Gladstone collar
that she favoured. He sent the picture to the first exhibition
(1882) of the Société internationale de peintres et sculpteurs
organised by the forward-thinking dealer Georges Petit. It
was exhibited as 'Pochade [a small format sketch expressing
colour and atmosphere]. Portrait of Vernon Lee'. Vernon Lee
was ambivalent about the art of portraiture, frustrated about
the contingent nature of the portrait form. Her reservations
may stem from a heightened sense of privacy, and she refused
publishers the use of any portrait of her, including Sargent's.

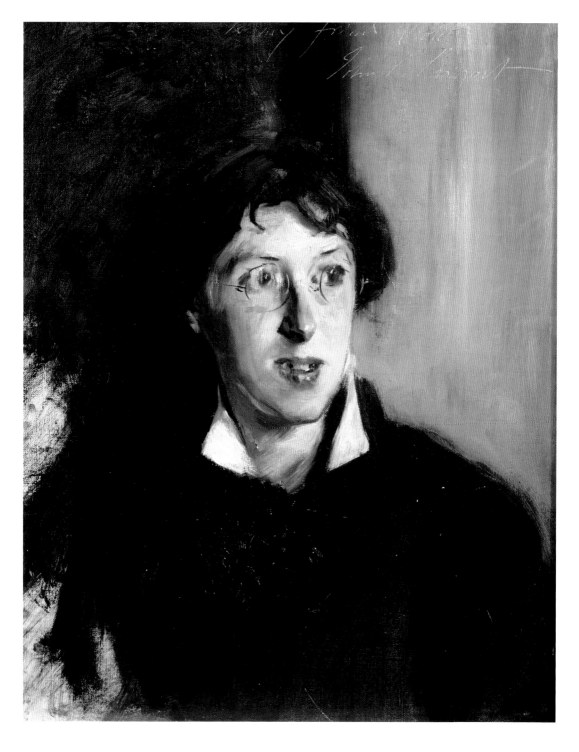

9. *Madame Allouard-Jouan*
*c.*1882

Oil on canvas, 750 x 558mm
Inscribed, upper left: *à Mme Allouard Jouan/témoignage d'amitié*
['to Madame Allouard Jouan/testament of friendship'];
upper right: *John S. Sargent*
Musée du Petit Palais, Musée des Beaux-
Arts de la Ville de Paris

The recent emergence of a cache of letters from Sargent
to the sitter reveal her to be Emma-Marie Allouard-Jouan
(1836–1918), born in Burgundy, married to Pierre Allouard
in Paris in 1859; divorced 1886. Well connected in the worlds
of the arts and politics, she was principally a translator but also
a novelist, as Émile Jouan-Rolland, and journalist, again using
pseudonyms, including Argus and Gygès. She was at the heart
of Sargent's circle in Paris, dining, for example, in January
1881, with (among others) Édouard Pailleron, Ernest-Ange
Duez, Carolus-Duran and the critic Louis Leroy at one of the
French writer and publicist Pierre Véron's regular Tuesday-
evening parties. Madame Allouard-Jouan had a summer house
in Dinard, Brittany, and was well acquainted with two other
Breton summer residents: Madame Pierre Gautreau and
Judith Gautier (no. 10). Her Breton home was close
to Château les Chênes, the Gautreaus' walled estate, and
Le Pré des Oiseaux (Gautier's home). During summer 1883,
when Sargent was painting Madame Gautreau at Les Chênes,
he moved to and fro between them. Sargent exhibited this
portrait at the Société internationale de peintres et sculpteurs
at Galerie Georges Petit in December 1882. A few critics
responded to its quiet sensitivity and dignity. In 'American
Pictures at the Salon' (*Magazine of Art,* 6, 1883), William
Brownell described it as 'a beautiful and sympathetic portrait
of a lady – a patrician whose blue blood Fortuny could not have
better rendered.' Henry James admired its skilful portrayal of
a woman of a certain age; as a fine depiction of experience.

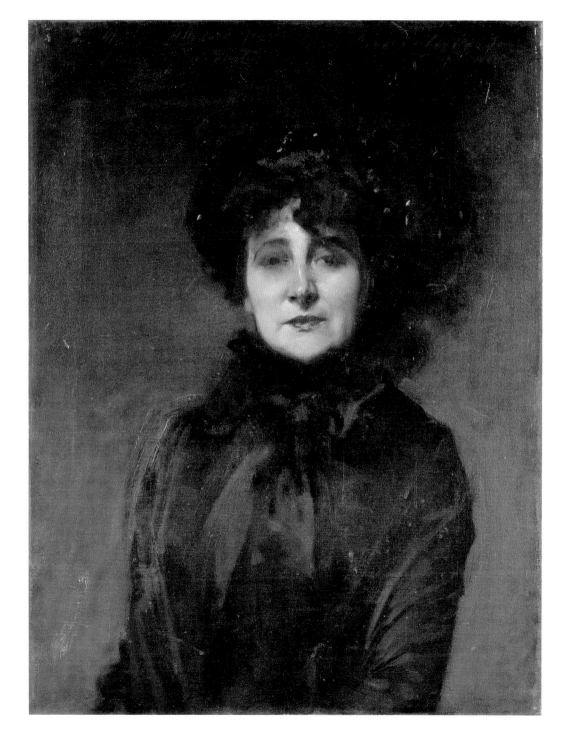

10. *Judith Gautier*
*c.*1883

Oil on panel, 991 x 622mm
Detroit Institute of Arts, Michigan, USA

Sargent painted a series of portraits of Judith Gautier
(1845–1917) in oil, watercolour, pen-and-ink wash and
pencil, probably all executed during the summer of 1883
when Sargent was in Brittany painting *Madame X*. The
Gautier portraits were possibly all uncommissioned works
presented to her as gifts. Judith Gautier was born into an
extraordinary, artistic family, the daughter of the French
writer and aesthete Théophile Gautier and his Italian mistress,
the operatic contralto Ernesta Grisi. The Gautier home was
host to such literary figures as Victor Hugo, Gustave Flaubert
and Charles Baudelaire. Gautier became a distinguished
Sinologist and translated Japanese and Chinese poetry; she
wrote reviews, usually for the radical *Le Rappel*, and plays;
played the piano and made sculpture. Gautier was aware of
Sargent at an early stage in his career and wrote important
reviews of works that he exhibited at the Salon, deeming him
an artist with an absolute sense of his own artistic personality.
Gautier was considered to be a great beauty. In this, the
most realistic of Sargent's portrayals, as well as the largest and
most ambitious, he describes her in an interior softened by
lamplight. She wears the loose, white or ivory-coloured robe
that she favoured, with flowers in her dark hair, which add
to the oriental mood. She is depicted in the context of her
own belongings: piano, sheet music, papers, dimly glimpsed
paintings, all bathed in a glowing and partially concealing
light, which perpetuates a certain sense of romantic mystery.

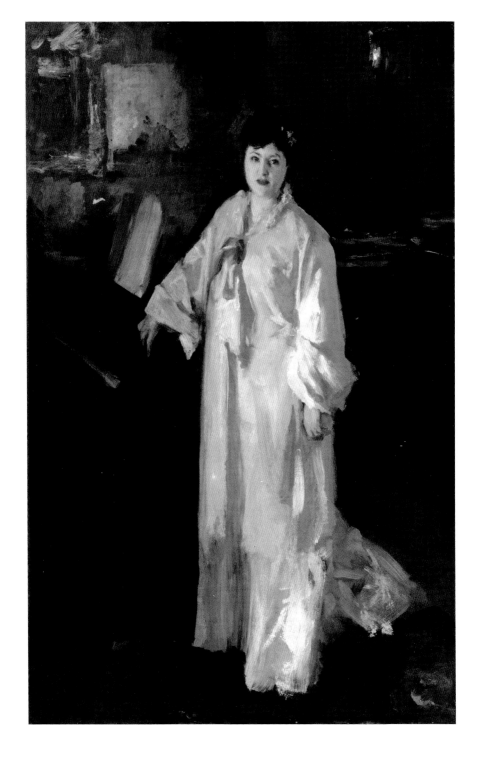

11. *Auguste Rodin*
1884

Oil on canvas, 725 x 525mm
Inscribed, across top: *à mon ami Rodin John S. Sargent
1884* ['to my friend Rodin John S. Sargent 1884']
Musée Rodin, Paris, France

Sargent probably met Auguste Rodin (1840–1917) in Paris
in the early 1880s. They breakfasted together in the quartier
Latin with the young portraitist Paul Helleu, and sometimes
with the writer Paul Bourget too. Sargent and Rodin were
among the artists whose work formed the first exhibition of
the Société des XX in Brussels in February 1884; they both
later exhibited at the Exposition internationale de peinture
at the Galerie Georges Petit. By August 1884, Rodin was
at work on a bust of Sargent, although it is not recorded in
Rodin literature and was probably not completed (Sargent
was notoriously reluctant to sit for his portrait). For his part,
Sargent had begun work on this portrait of Rodin, painting
him as a venerable figure. There is nothing to distract from his
finely modelled head, which emerges from a dark and sober
background. In later years, Sargent introduced Rodin to the
society hostess Mrs Charles Hunter, and Rodin modelled a
bust of her. Both Sargent's portrait of Mrs Hunter (1898) and
Rodin's bust (1906) are in the Tate's collection. When Rodin
saw Sargent's group portrait of Mrs Hunter's daughters, *The
Misses Hunter* (Tate, UK), at the Royal Academy in 1902,
he was moved to describe him as a modern Van Dyck. A
sepia-wash drawing of Rodin by Sargent of 1902 is in the
Cantor Arts Center, Stanford University. In addition, Sargent
owned three pen-and-ink studies by Rodin of a group
after Clodion, *Adoration and Lovers,* which featured in the
artist's sale at Christie's, London, on 24 and 27 July 1925.

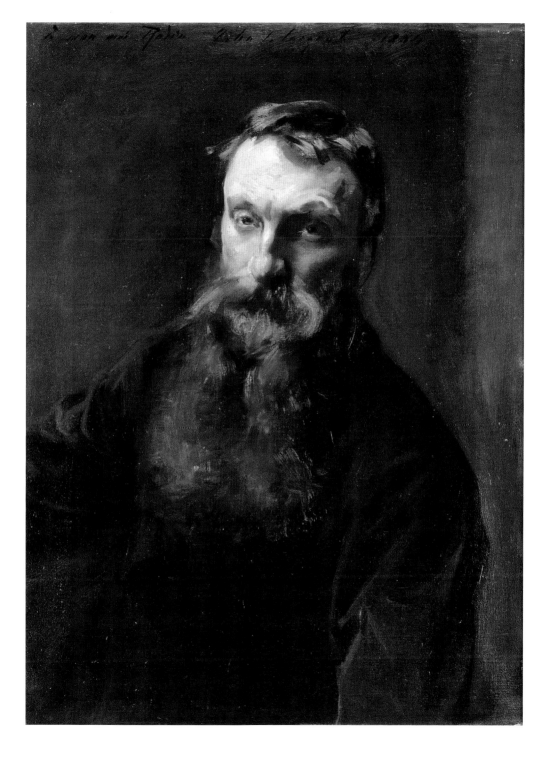

12. *Claude Monet, Painting,*
 by the Edge of a Wood
 probably 1885

Oil on canvas, 540 x 648mm
Tate, UK

Sargent usually presented his sketches of friends and fellow artists as gifts to them, as was the tradition in artistic circles. This sketch of Claude Monet (1840–1926) remained with Sargent all his life and was in his studio when he died. Sargent shows Monet painting a recognisable landscape. The line of the trees, the delicately flushed sky, the clump of haystacks and the larger haystack on the left, almost certainly identify it as *Meadow with Haystacks near Giverny* (1885, Museum of Fine Arts, Boston), though the colours in Monet's canvas are more highly keyed than Sargent's representation of them. This modest painting has assumed an importance in the history of Impressionism because it shows the French artist doing what he advocated, painting *sur le motif* and *en plein air*; it may be also that it had a personal significance for Sargent. There is no doubt that Sargent revered Monet. By the autumn of 1885, when Sargent was experimenting with landscape and figures painted under real conditions of light and, technically, beginning to use a brighter palette and more broken brushwork, he was asking Monet about pigments (possibly with regard to *Carnation, Lily, Lily, Rose*, no. 15). Sargent's admiration for Monet accelerates around this time, and he begins his own Monet collection. In later years, Sargent was Monet's reference point in London, both personally and professionally. There may not have been perfect concord between the two professionally, but there was genuine personal attachment and, on Sargent's side, absolute artistic respect.

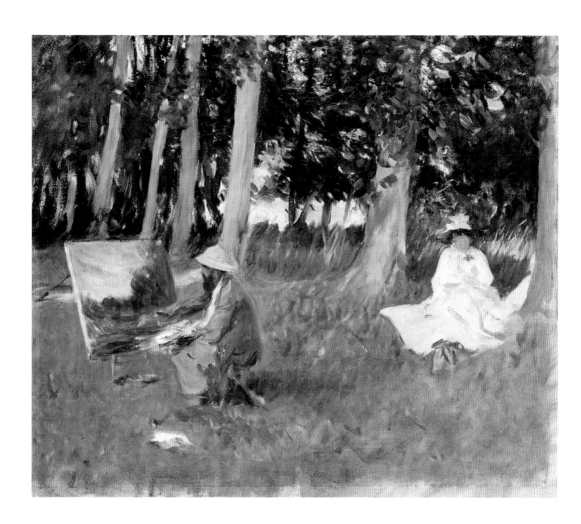

13. *Fête familiale*
*c.*1885(?)

Oil on canvas, 609 x 737mm
Minneapolis Institute of Arts, Minnesota, USA

This innovative family conversation piece relates to other interior scenes by Sargent of the mid-1880s that have a predominantly red tonality: *A Dinner Table at Night* (no. 14) and *Robert Louis Stevenson and His Wife* (no. 18). *Fête familiale* does not present itself as a scene from everyday domestic life, however: it marks an occasion. The French artist Albert Besnard (1849–1934) and his wife, the sculptor Charlotte Dubray (1855–1931), are celebrating the birthday of their eldest child, Robert. The table with its white cloth performs a similar function to that in *A Dinner Table at Night*, leading the spectator into an intimate scene yet separating him or her from at least one of the people portrayed (in such unorthodox compositions, they can hardly be referred to as sitters). It sets up an ambiguity that is strengthened by the positioning of the figures. The birthday boy's face is illuminated by the overhanging light, but Madame Besnard is the dominant figure; Besnard is relegated to the background, virtually faceless. Besnard espoused what he called the 'environmental' portrait, using his sitters' surroundings to represent character and their relationship with their world. Sargent is painting in a similar vein, using the details of the room to suggest the Besnards' aesthetic tastes. The world of the arts in Paris was a small one at this period, and Besnard and his wife formed part of the overlapping circles of friendships between artists and musicians with whom Sargent associated. Besnard gave Sargent a painting in exchange for *Fête familiale*: a large full-length female figure, *Le Remords*.

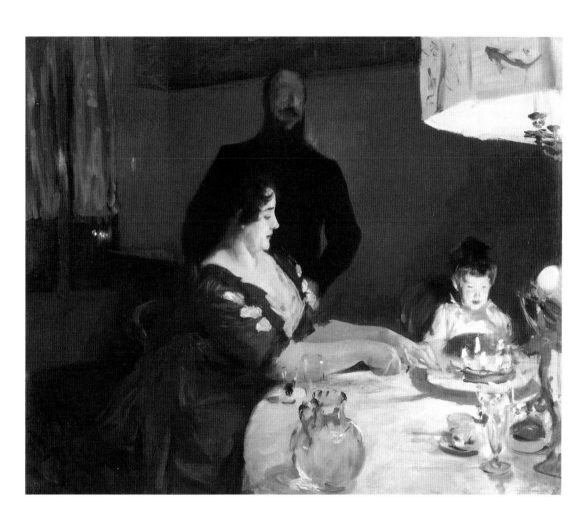

14. *Le Verre de Porto (A Dinner Table at Night)* *(The Glass of Port)* 1884

Oil on canvas, 514 x 667mm
Inscribed, lower right: *John S. Sargent*
Fine Arts Museums of San Francisco, California, USA

In 1884, Sargent made two visits to Sussex, painting a full-length portrait of Edith Vickers (Virginia Museum of Fine Arts) and two less formal studies, including one of Edith and her husband, Albert. This picture represents the dining room of the Vickerses' home, Lavington Rectory in Beechwood. Designed to appear without artifice, it is as if the scene had been lighted upon, the moment after dinner when the table has been cleared, a moment of pause between this and that. There is no story or anecdote and little information. Only half a face in profile registers the identity of Albert Vickers (1839–1919), though Edith Vickers (d.1909) is represented frontally, looking out at the spectator. While apparently the stuff of civilised life, a hint of disquiet inhabits the imbalance between the figures, the insistent reds and the large vacant shadow to the left. Sargent would use similar devices, the interior setting, the reddish tonality and the unorthodox disposition of the figures, in another double portrait-that-is-not-quite-a-portrait, *Robert Louis Stevenson and His Wife* (no. 18), and in *Fête familiale* (no. 13). In Paris, the painting was shown with the title *Le Verre de Porto (Esquisse)*. The word *esquisse*, meaning 'sketch', with its suggestion of incompleteness, must have been a deliberate, possibly defiant choice. Though handled freely and with loosely defined brushwork, the painting is a finished work. Its modest scale, the informal and inconsequential nature of its subject matter, the oddness of the point of view and the sketchiness of the still-life details signal the picture's modernity as much as the facture does.

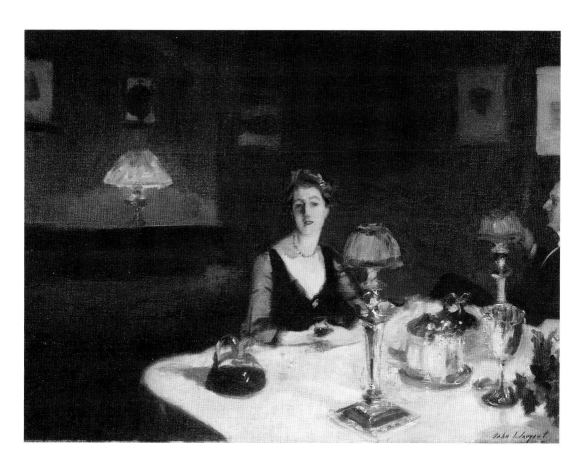

15. *Carnation, Lily, Lily, Rose*
1885–6

Oil on canvas, 1740 x 1537mm
Inscribed, upper left: *John S. Sargent*
Tate, UK

In 1885, during a Thames boating trip, Sargent saw two girls lighting paper lanterns at dusk in a garden planted with roses. This was the direct inspiration for this work, painted at Broadway, Worcestershire. Sargent had almost certainly been to Giverny and seen Claude Monet painting out of doors, *sur le motif*. In contemporary French art, natural, not studio, light was becoming key, and Sargent's principal imperative was the transcription of fugitive evening light. He is not, however, painting an apparently random scene as Monet might have done. This is a deliberately conceived and constructed work. *Carnation, Lily, Lily, Rose* is poised between several aesthetics: French Impressionism, English Pre-Raphaelitism and Aestheticism. It is allusive, layered with literary and musical associations, and elusive in that it elides meanings and fuses traditions. The flower imagery references Italian Renaissance paintings and their poetic symbolism, and the lily – purity, innocence and ideal beauty – was a signal flower for Pre-Raphaelite and Aesthetic writers and artists. The title comes from a popular composition for three voices, 'The Wreath' by Joseph Mazzinghi, described on the sheet music as a 'pastoral glee'. Baudelaire's *Les Fleurs du mal* (1857) offers a possible decadent context. The prettiness and innocence of the picture is beguiling, but there are disquieting undertones in the over-sized lilies that loom over the girls in a compressed picture space. Several contemporary writers chose music as their critical framework for interpreting Sargent's work. Vernon Lee (no. 8) likened the particular pleasures of this one to the slow movement of Mozart quartets.

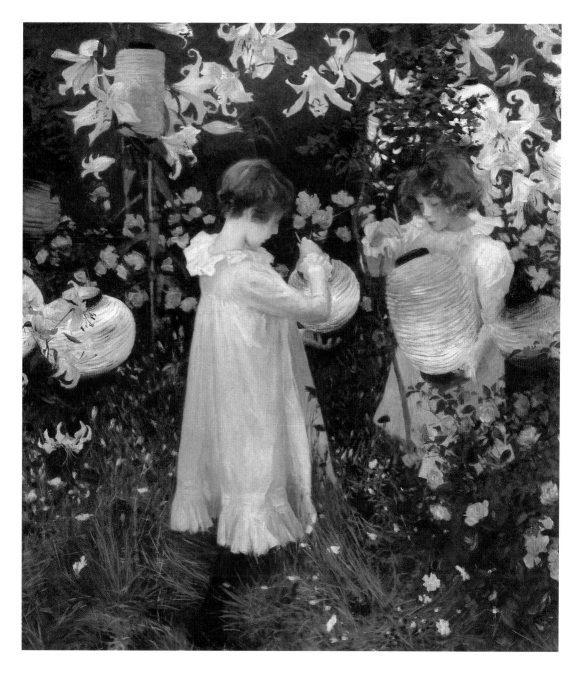

16. *Mrs Frank Millet*
probably 1885–6

Oil on canvas, 883 x 673mm
Inscribed, upper left: *to my friend Mrs Millet*;
upper right: *John S. Sargent*
Private Collection

Lily Millet (1855–1932), wife of the American artist Francis
'Frank' D. Millet, was at the centre of the community of
artists and writers at Broadway in Worcestershire. Sargent
was devoted to the Millets. He inscribed sketches to Lily,
painted pictures of their house and garden, and portraits of
their children (one of whom, Kate, was the first model for
Carnation, Lily, Lily, Rose, no. 15). The Millets' youngest child,
John Alfred Parsons Millet, was named after Sargent and
another Broadway artist, Alfred Parsons. Resident or visiting
writers, including Henry James, recall Sargent painting a
portrait of Lily Millet at Broadway in 1885 and again in 1886.
The following year, Frank Millet's sister, Lucia, told how Mr S,
as she describes Sargent, was beginning the painting afresh
each day. Equally, the wife of the American sculptor Daniel
Chester French saw Sargent scraping down the canvas a
number of times before he produced an image he liked. The
portrait, in a rectangular frame with an oval spandrel, appears
in a painting by Frank Millet of an interior scene, *How the
Gossip Grew*, exhibited at the Royal Academy, London, in
1890. A pen-and-ink caricature (private collection) after the
portrait was drawn by one of the Broadway party as a place
card for Lily's birthday celebrations in September 1886. The
portrait had an afterlife. In 1902, Lily Millet sent a photograph
of it to Henry James, who, in response, told her how the
picture reminded him of the delights of summers past.

17. *Edmund Gosse*
1886

Oil on canvas, 611 x 508mm
Inscribed, across top: *to Edmund Gosse
from his friend John S. Sargent*
Leeds University Library, UK, Brotherton Collection

Edmund William Gosse (1849–1928) was a literary historian,
translator and critic. He held positions at the British Museum,
the Board of Trade and the House of Lords Library, wrote
poetry, criticism and biography, and translated *Hedda Gabler*
(1891) and *The Master Builder* (1892, with William Carter),
which introduced Ibsen's work to the British public. His
memoir, *Father and Son* (1907), is a minor classic, an account
of his childhood and psychological escape from a puritanical
Plymouth Brethren father to the exciting world of art and
literature. In 1875, Gosse married an artist, Ellen Epps, who
had studied with Sir Lawrence Alma-Tadema and whose
sister Laura became Alma-Tadema's second wife. At the
time this portrait was painted, Gosse was Clark lecturer in
English Literature at Trinity College, Cambridge. It was
probably Henry James who introduced Gosse and Sargent
in summer 1884, following a request by James for Gosse to
'second' Sargent, so that he might be introduced at London's
Savile Club. In a frequently quoted anecdote about a portrait
of Gosse painted in the open air, Gosse is specific that it
was in the hot August of 1885 (when he and Sargent were
at Broadway); he had walked, hatless, into a white-washed
farmyard, where Sargent, painting at noon under a cloudless
blue sky, enthused about Gosse's striking lilac hair. Neither
this portrait, nor that in the collection of the National Portrait
Gallery, London, look as if it were painted out of doors,
however, although it is an engaging story and interesting with
regard to Sargent's responsiveness to the effects of light.

18. ## Robert Louis Stevenson and His Wife

1885

Oil on canvas, 514 x 616mm
Inscribed, upper left: *to R.L. Stevenson,*
his friend John S. Sargent 1885
Crystal Bridges Museum of American
Art, Bentonville, Arkansas, USA

Sargent had known Robert Louis Stevenson (1850–94) since his early years in Paris when he studied with Stevenson's cousin, R.A.M. Stevenson, under Carolus-Duran. Sargent painted three portraits of Robert Louis Stevenson, the first of which (1884) has not survived. This, the second, was painted in Skerryvore, the Stevensons' house in Dorset, in 1885, when Stevenson's literary star was in the ascendancy. Sargent's study, in which he represented Stevenson in characteristic walking-and-talking manner, constructs an apparently accidental, snapshot-like composition. The figures are framed as if caught by a photographic eye, as in *A Dinner Table at Night* (no. 14), a bisection of vision that suggests the influence of Edgar Degas. Sargent uses the space between his figures as a charged interval, as he had in *The Daughters of Edward Darley Boit* (1882, Museum of Fine Arts, Boston), to imply tension and unease. Although different in scale from the latter, the study of Stevenson and his wife explores the image of an open doorway, through which the eye is led into a mysterious space. The template for this is Velázquez's *Las Meninas* (1656, Museo Nacional del Prado, Madrid), which Sargent copied during his visit to Spain in 1879. Fanny Stevenson (1840–1914) is the peripheral, apparently passive figure in the painting, despite her redoubtable personality. In any event, the protagonists were not deterred by the eccentricity of the composition and found it engagingly odd. Exhibited at the New English Art Club in 1887, the picture later hung in the drawing room at Skerryvore, where Henry James saw it and was charmed.

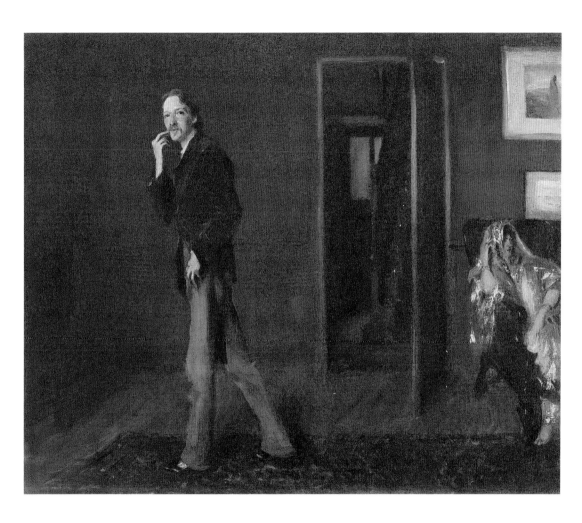

19. *Self-Portrait*
1886

Oil on canvas, 345 x 297mm, oval
Inscribed, upper left: *John S. Sargent 1886*
Aberdeen Art Gallery and Museums Collections

Alexander Macdonald, a granite merchant and fine-art
collector from Aberdeen, initiated a collection of what
became ninety-one portraits (the majority self-portraits).
Uniform in size and shape, they span 1880–97; Sargent's
portrait is dated 1886. Macdonald died in 1884, but his wife,
Hope Gordon Macdonald, continued his enterprise. Sargent
was an unusual choice at this relatively early stage in his
career. The reason for the selection is not known, but the
point of contact was probably Joseph Farquharson, a Scottish
artist later known for his wintry landscapes and treatment of
light. Farquharson must have been acquainted with Alexander
Macdonald (Farquharson's self-portrait, in which he wears a
tam-o'-shanter, is in the Macdonald collection). Sargent had
known Farquharson since boyhood, and they both studied
with Carolus-Duran in Paris. Farquharson seems to have
promoted Sargent early in his career. He was the driving force
behind two portraits painted during Sargent's visit to London
in 1881: *Robert Farquharson* and *Poppy Graeme*, both painted
in Farquharson's London studio. Sargent and Farquharson
also met up in Egypt in 1891: Sargent had travelled there to
research his Boston Public Library murals. Sargent represents
himself here in semi-profile, dressed conventionally in a grey
suit, stand-up collar and dark tie with white spots. There are
two later self-portraits (1892, National Academy Museum,
New York; 1906, Uffizi Gallery, Florence). The celebrated
collection of artists' self-portraits in the Uffizi Gallery,
Florence, may have been the inspiration for Macdonald's
collection. G.F. Watts's Hall of Fame project, comprising
portraits of eminent Victorians, is another point of reference.

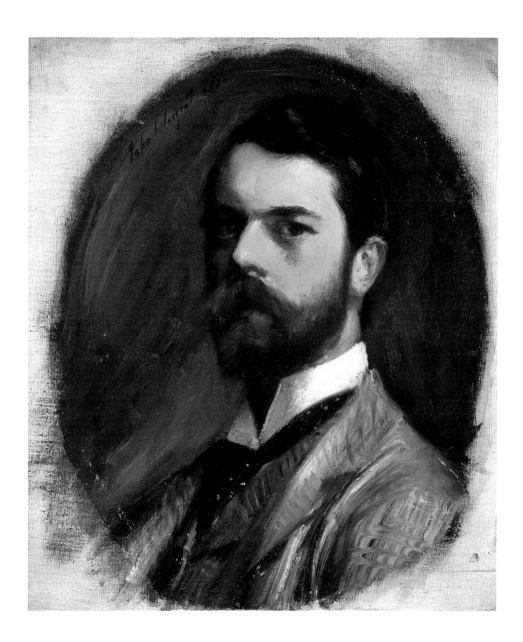

20. An Out-of-Doors Study (Paul Helleu Sketching with His Wife)

1889

Oil on canvas, 659 x 807mm
Inscribed, lower right: *John S. Sargent*
Brooklyn Museum, New York, USA

In the summer of 1889, the French artist Paul Helleu (1859–1927) and his wife, Alice (1870–1933), were among the visitors to Fladbury Rectory in Worcestershire, where Sargent was staying with his family and where this Impressionist study of an artist at work out of doors was painted. In this work, a painting about the act of painting, Sargent's models are well realised and characterised; Helleu's intense concentration and the listless demeanour of his wife put it on the borderline of figure-in-a-landscape and *plein-air* portraiture. There is no horizon line and no sky to place the scene in space, the picture plane is tilted, and there is a lack of spatial recession. All this announces an experimental work, but the design is deliberately constructed. Helleu, just off-centre, is the focal point; his wife seems to slide away from him, but, together, the two figures form a mass that anchors and structures the composition. Several lines create a geometric pattern: the thin easel support bisecting the canvas vertically and the bright red canoe slicing it diagonally. The energy of the brushwork, the slashing strokes of the reedy riverside grasses, do nothing to undermine the tautness of the underlying structure. The existence of preliminary or related sketches reinforces the idea that this was a considered work. However, when it was shown in America in 1890, it received little critical attention, overshadowed by the, at least superficially, Monet-esque *A Morning Walk* (1888, private collection); exhibited in London two years later the picture again attracted scant regard.

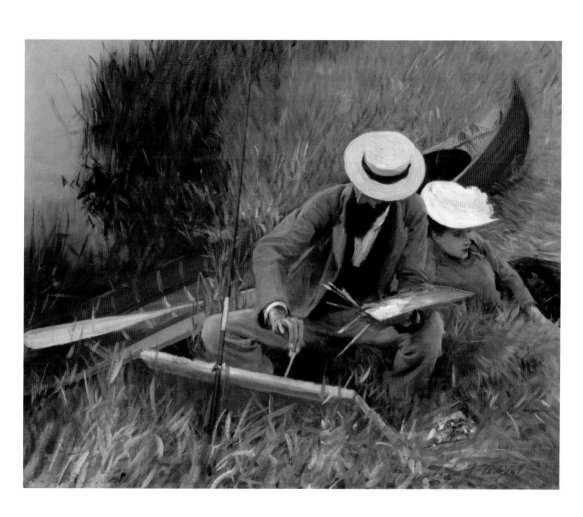

21. *Portrait of George Henschel*
1889

Oil on canvas, 635 x 533mm
Inscribed, upper left: *to my friend Henschel*;
upper right: *John S. Sargent. '89*
Crystal Bridges Museum of American
Art, Bentonville, Arkansas, USA

George Henschel (1850–1934) trained as a pianist before
turning to singing and developing a fine baritone voice. He
and his first wife, the soprano Lillian Bailey, gave joint recitals
in the early 1880s. Henschel served as the first conductor
(1881–4) of the Boston Symphony Orchestra, established
the London Symphony Concerts in 1886 and went on to
conduct the Royal Scottish National Orchestra (1893–5). His
own compositions include instrumental works, an opera and
a requiem. He and Sargent first met in the summer of 1887
at the Henley home of the music devotee Robert Harrison,
whose wife Sargent had painted the year before (Tate, UK).
Henschel was attracted by the personality of the painter and
impressed by his talent as a pianist and wide knowledge of
music. Sargent in turn became an ardent admirer of the singer.
The portrait was an homage from one artist to another, in
approximately five sittings – or standings, given that Henschel
stood for Sargent, on a platform, singing. Adèle Chapin,
who saw the finished portrait in Sargent's studio, asked how,
pointing to the picture of a society hostess, he could bear to
paint like that, when, pointing to Henschel, he could paint
like this. To which Sargent replied that it was simply that
he loved Henschel. There is about the portrait the air of an
inspired performer, face lit up, lips parted, eyes upturned
and far-seeing – the singer in thrall to his art. When shown
the portrait for the first time Henschel's wife remarked on
its beauty – how George appeared to be touching heaven.

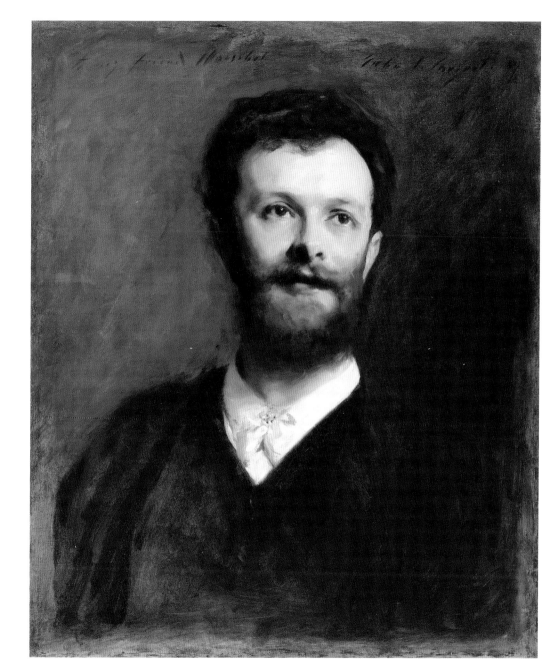

22. *Gabriel Fauré*
*c.*1889

Oil on canvas, 610 x 546mm
Inscribed, across top: *à Gabriel Fauré souvenir affectueux John
S. Sargent* ['to Gabriel Fauré, affectionately John S. Sargent']
Collection Musée de la Musique, Paris, France

Gabriel Fauré (1845–1924) ranked high in Sargent's pantheon
of great composers – perhaps only Wagner ranked higher.
Sargent had met Fauré in the mid-1880s through friends
and neighbours, when Fauré's music, with its harmonic
and melodic innovations, was not universally admired. His
reputation was, however, spurred on by a devoted group
of friends and patrons, of whom Sargent was one. Sargent's
portrait of Fauré is a testament to that friendship and almost
certainly painted in 1889 when Sargent came over to Paris
for the Exposition Universelle, where a number of his
portraits were on display. Sargent's portrait of Fauré captures
his charismatic personality and good looks, giving him a
somewhat imperious expression, with his characteristic
'chin-up', gazing into space. Highlights gloss the composer's
greying, bushy hair and moustache, and his starched white
collar. He looks every inch a creative genius. Following his
move to London in 1886, Sargent was active in promoting
Fauré on the London musical scene, organising studio concerts
at which Fauré's music was played and badgering his wealthy
friends to do the same. When Fauré came to London, as for
example in 1898 and 1908, he was always entertained and
fêted by Sargent. It was on the first of these occasions that
Sargent made two informal charcoal drawings of Fauré at a
house party held by the arts patron Leo Frank Schuster. At
the end of Fauré's life, when he fell on hard times, Sargent
sent him 2,000 francs; in return Fauré gave the painter
the manuscript of his second Piano Quintet (Op. 114).

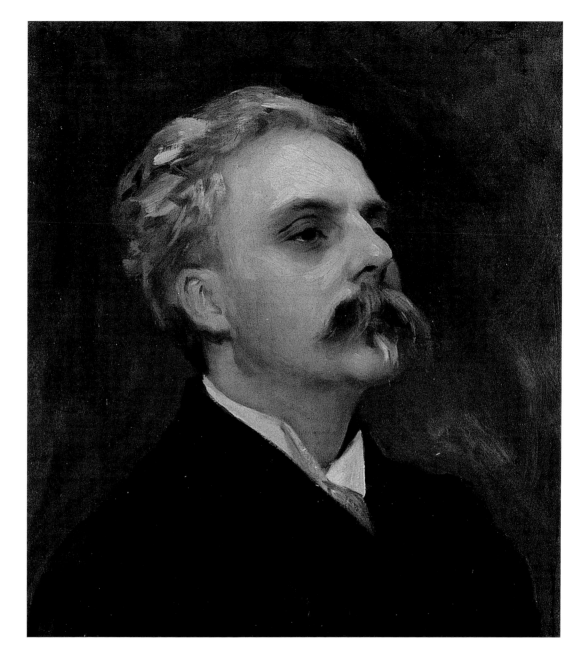

23. *Ellen Terry as Lady Macbeth*
1889

Oil on canvas, 2210 x 1143mm
Inscribed, lower left: *John S. Sargent*
Tate, UK

Ellen Terry (1847–1928) first played Lady Macbeth in
Henry Irving's production at the London Lyceum on 27
December 1888, performing opposite the actor–manager.
Sargent was in the first-night audience and so bowled over
by the actress's appearance that he determined to paint her.
Whatever inducements he offered to persuade Terry to sit,
his persistence paid off. An oil sketch of her sweeping out of
Macbeth's castle by torchlight to great Duncan may represent
Sargent's first idea for the picture. If so he abandoned this
theatrical scene for a static pose, against a neutral background,
showing the actress placing the crown on her head after
Duncan's murder. The incident does not occur in Shakespeare's
text, nor was it, according to contemporary accounts, a part
of Ellen Terry's performance. However, Sargent needed a
dramatic motif to make his portrait convincing both as the
personification of a role as well as the characterisation of an
individual actress. Ellen Terry herself appreciated the finished
picture's magnificence; when shown at the New Gallery,
in spring 1889, it became the sensation of the year. Terry's
dress, designed by Alice Comyns Carr, a close friend of the
artist, was of green silk and blue tinsel sewn all over with red
beetle wings, with a border of Celtic design decorated with
rubies. It provided Sargent with a field day for Impressionist
fireworks and scintillating brushwork. Henry Irving, who
was himself sitting for Sargent at this time (a portrait he so
disliked that he destroyed it), acquired the portrait, and it
hung for years in the Beefsteak room at the Lyceum Theatre.

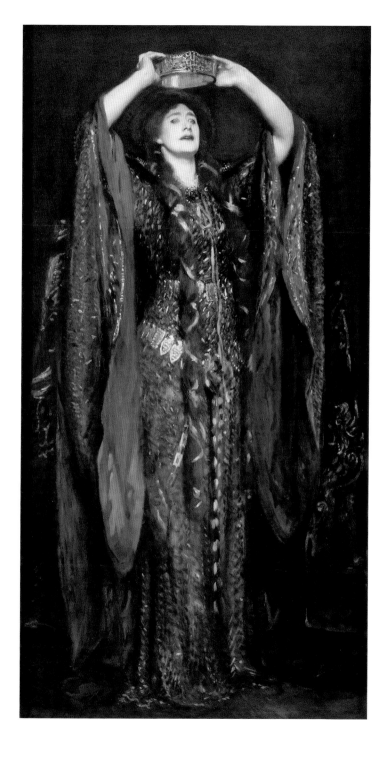

24. *Mrs George Batten Singing*
1897

Oil on canvas, 889 x 432mm
Inscribed, across top: *to Mrs G. Batten John S. Sargent*
Glasgow Life (Glasgow Museums) on behalf
of Glasgow City Council, UK

Sargent was caught up in the musical world of London in
the 1890s, a time when a great deal of music was played
in private houses. Among his close friends was Mrs Henry
Seymour Trower, a wealthy music lover and art collector, at
whose home in Surrey, in 1893, Sargent first heard Mabel
Batten (*c.*1857–1916) sing, recording her in a drawing he
gave to Mrs Trower (private collection). The beautiful and
talented Mrs George Batten (née Mabel Veronica Hatch) had
married the private secretary to the British viceroy in India,
George Batten. Back in London, she lived life in the fast lane,
becoming the lover of the Prince of Wales, among others,
and setting up house with the novelist Radclyffe Hall. A
prominent patron of music and the arts, she became a leading
mezzo-soprano, albeit amateur; it would have been déclassé
to turn professional. She also played the piano and guitar,
composed her own songs and set others to music. Inspired to
paint her in oils, Sargent shows Mabel Batten carried away in
song, reportedly the last note of 'Goodbye' by Paolo Tosti, the
master of music to Queen Victoria and professor of singing at
the Royal Academy of Music. At some point, he condensed
the composition and heightened the drama by cropping
her arms, thus emphasising her embonpoint, the ellipsis of
her necklace and her wasp waist. Dressed in an opulent silk
evening gown, Mrs Batten was evidently painted by lamplight,
her face and figure transformed by the luminous uplighting.

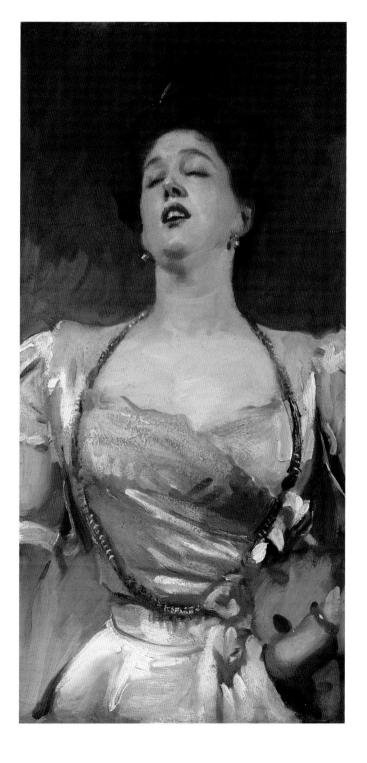

25. *W. Graham Robertson*

1894

Oil on canvas, 2305 x 1187mm
Inscribed, lower right: *John S. Sargent 1894*
Tate, UK

This exquisite youth, with his elegant, patrician air, his Chesterfield overcoat, jade-topped cane and poodle companion, sums up the 1890s *fin-de-siècle* spirit, its civilised detachment, air of decadence and obsession with beauty. Walford Graham Robertson (1866–1948) stands before a Japanese lacquer screen of a type much admired by the Aesthetes; there were several in Sargent's studio. He poses as a youthful dandy, but he was twenty-eight at the time, a gifted illustrator of children's books and a talented theatre designer. Robertson had trained in the studio of Albert Moore and moved in Aesthetic art circles, counting Edward Burne-Jones, James McNeill Whistler, Thomas Armstrong and Walter Crane among his friends and mentors. He had designed sets and stage costumes for Sarah Bernhardt and Ellen Terry, and later became a playwright with the successful production of *Pinkie and the Fairies* (1908). He was independently wealthy, and his art collection included much William Blake and masterpieces by G.F. Watts, Burne-Jones and Whistler. Robertson is best remembered now for his charming period memoir, *Time Was* (1931). The portrait, one of Sargent's masterpieces, was painted at the artist's request. He had been struck by Robertson's paintable looks when he accompanied his mother, whom Sargent was painting (*Mrs Graham Robertson*, 1880, Watts Gallery, Compton, Surrey), as well as by the lines of his long overcoat and his poodle, Mouton, who provided comic relief by regularly biting the artist during the eventual sittings. To Robertson's objection to wearing an overcoat in the summer, Sargent protested that the coat was the picture.

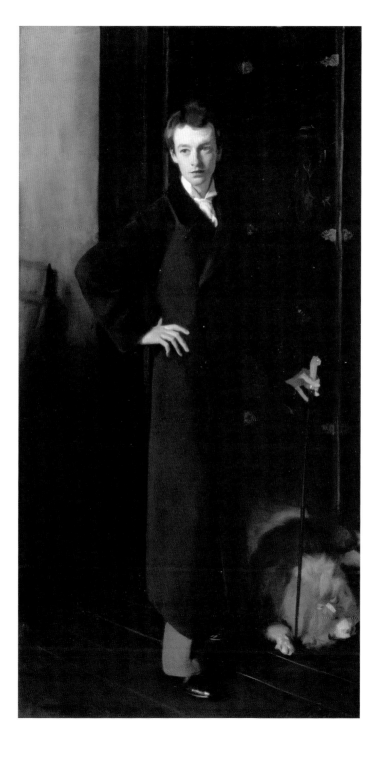

26. *Henry James*
1913

Oil on canvas, 851 x 673mm
Inscribed, upper left: *John S. Sargent*;
upper right: *1913*
National Portrait Gallery, London, UK

Sargent's relationship with the novelist Henry James (1843–1916) has inspired more column inches than any other in the biography of the artist. They were the two greatest recorders of the transatlantic social scene in their respective arts and close friends for more than forty years. James remained an acute and generally supportive critic of Sargent's work, while the artist paid tribute to the writings of his friend. Sargent had first drawn James in a profile portrait of 1886 (private collection); then in a second, unsatisfactory charcoal drawing in 1911 (Royal Collection Trust, UK). In 1913 the novelist's friends commissioned Sargent to paint his portrait in celebration of his seventieth birthday. Sargent confided to James that he had rather lost confidence, having done no portraiture in the preceding few years. However, once the sittings (some ten or so) were under way, he got into his stride. Sargent's portrait is a masterly study of an enigmatic literary genius. The domed head is luminous with intelligence and a sense of introspective rumination. The play of lights and darks keeps the face mobile and alive, accentuating or shadowing certain features. The way James sits a little aslant in the chair, with his left arm hooked over its back, gives the image a studied informality. Especially telling is the way the thumb hooks into the armhole. James himself was delighted with the finished work, deeming it a masterpiece that showcased Sargent at his best; himself not at his worst. At the 1914 Royal Academy Summer Exhibition, a suffragette slashed and seriously damaged the portrait.

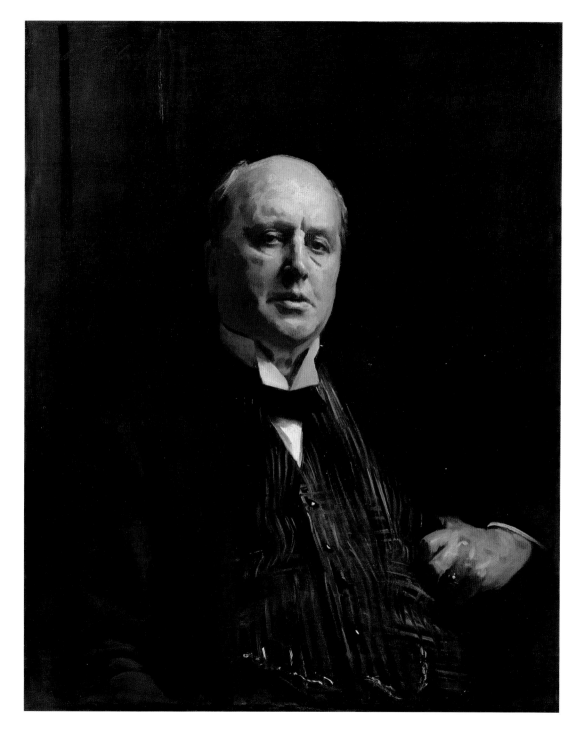

27. William Butler Yeats
1908

Charcoal on paper, 622 x 470mm
Inscribed, upper right: *John S. Sargent / 1908*
Private Collection

Arguably the greatest English-speaking poet of his generation, Yeats (1865–1939) was Irish-born and deeply involved in both the Irish literary renaissance and Irish politics. He established his reputation with his early lyric poems and his Celtic plays. He was one of the founders of the Abbey Theatre in Dublin and later of the Irish Academy of Letters. Latterly, he was much preoccupied with spiritualist experiments and theories. Exceptionally good-looking in youth, Yeats cultivated his appearance as a poet and an aesthete, wearing a velvet coat and bow tie as a reminder of his elevated status as an artist. Sargent was not one for poseurs, but he and Yeats established a rapport that comes across in the portrait: a subtle, moody characterisation of a gifted writer. The drawing of Yeats was commissioned as the frontispiece to the first volume of his *Collected Poems* (1908). In April 1908 the poet told the lawyer and collector John Quinn that he found the portrait flattering; that he enjoyed Sargent's company, considering him less an artist than a well-heeled businessman who consorted with artists. Quinn quickly acquired the drawing, admiring it for its marble-like clarity and precision. Sargent's connection with Irish literary circles and Irish nationalism was not confined to Yeats. Through the art dealer Hugh Lane, whose portrait he also painted (1906, Dublin City Gallery The Hugh Lane), he met Lady Gregory, a central figure in the Irish Celtic Revival; he was a close friend of Erskine Childers, author of *The Riddle of the Sands* (1903), and later an IRA gunrunner executed by the British.

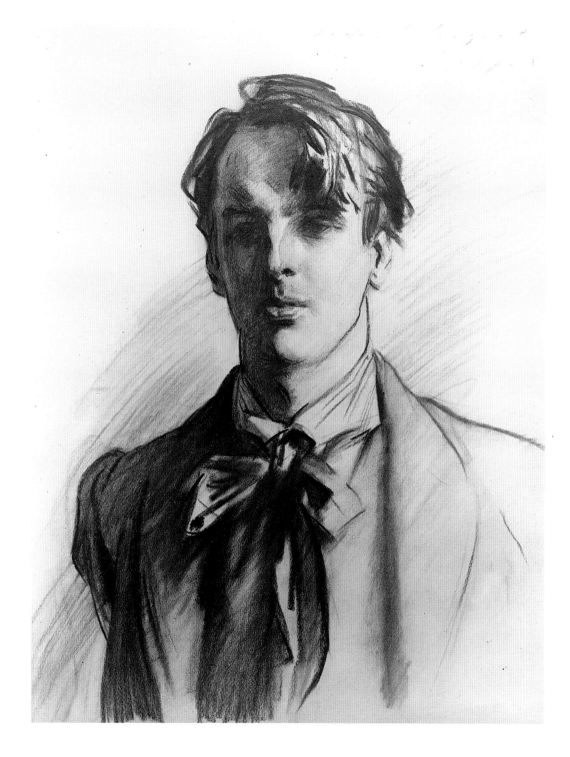

28. *La Carmencita*
1890

Oil on canvas, 2320 x 1420mm
Inscribed, upper left: *John S. Sargent*
Musée d'Orsay, Paris, France

Between 1889 and 1890, Sargent painted three of his greatest theatrical portraits: *Ellen Terry as Lady Macbeth* (no. 23), *Edwin Booth* (no. 29) and *La Carmencita*. Sargent may have first encountered the last-named, born Carmen Dauset in Almeria, Spain, when she scored a hit at the 1889 Exposition Universelle in Paris, taking New York by storm a year later. Sargent saw her in music hall on 14th Street on 17 February 1890. With his passion for Spanish dance and music, he found La Carmencita (1868–1910) electrifying and persuaded her to let him paint her, though she was a restless and demanding sitter. Sargent may have conceived the portrait as a dance picture, along the lines of *El Jaleo* (1882) – his early flamenco masterpiece – but he opted instead to show her stationary, hand on hip, one leg extended. Her yellow silk dress, embroidered with lace and silver, balloons like a bell, and a matching silk shawl criss-crosses her upper body. Her face, like that of several Sargent models of the time, is rendered *à la japonaise*, white and mask-like, with arched eyebrows, hinting at a proud, even cruel presence. A flower in her black hair completes the effect. Sargent painted the portrait *con brio*, leaving parts all but unfinished. He himself called it sketchy, a criticism others echoed. Nevertheless the picture caused a sensation in New York, London and Paris, its subject seen as both appealing and repellent; the work itself eclipsing other exhibits. In a final accolade, the French state purchased it for the Musée du Luxembourg in Paris.

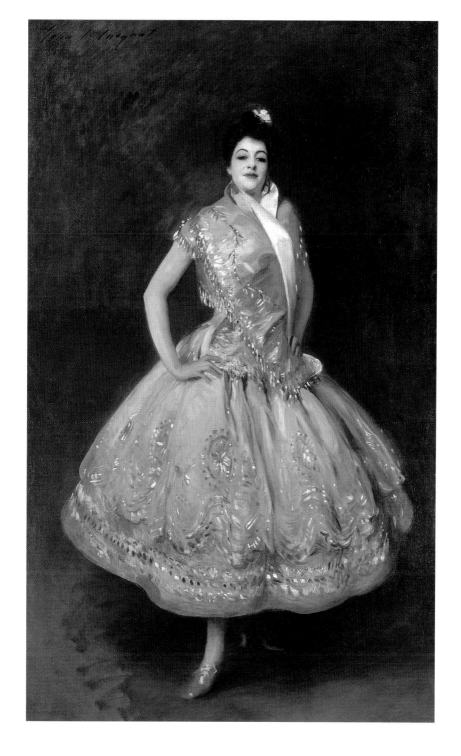

29. *Edwin Booth*
1890

Oil on canvas, 2223 x 1568mm
Inscribed, upper left: *John S. Sargent*
Amon Carter Museum of American
Art, Fort Worth, Texas, USA

It was as portraitist-extraordinary to The Players Club in New
York that Sargent came to create a trio of American theatre
portraits, beginning with Booth (1833–93). The veteran
American actor, renowned for his Shakespearian roles, had
founded The Players in Gramercy Park, New York, in 1888,
as a meeting place for theatre folk and those from other
professions. As a token of their regard for Booth, the newly
elected members of the Club decided to commission a portrait
of their founder. The actor initially sat for the artist in January
1890; after the second sitting, he expressed his disappointment
at the portrayal to a friend. When Booth's reaction to the
portrait reached Sargent, he painted out the head and began
again. The finished portrait is one of Sargent's greatest
creations. Booth stands in proprietary mode before the marble,
Renaissance-style fireplace in the Great Hall of the Club. The
unusually wide format facilitates the dramatic atmosphere
of the scene, in which the fire, the sinister fire-iron and the
enormous corbel of the mantelpiece play supporting roles.
Booth appears as if in role, his lithe figure expressing as much
nervous force and tension as his pale features, compressed
lips and searching gaze. Especially memorable are the hands
with thumbs tucked into his pockets, a pose he often assumed
on stage. Booth had suffered personal tragedies: his younger
brother, John Wilkes Booth, had murdered Abraham Lincoln;
he had suffered financial reverses alongside triumphs. All this
is in the portrait, for Booth wears a tragic, haunted look,
alongside a masterful self-confidence.

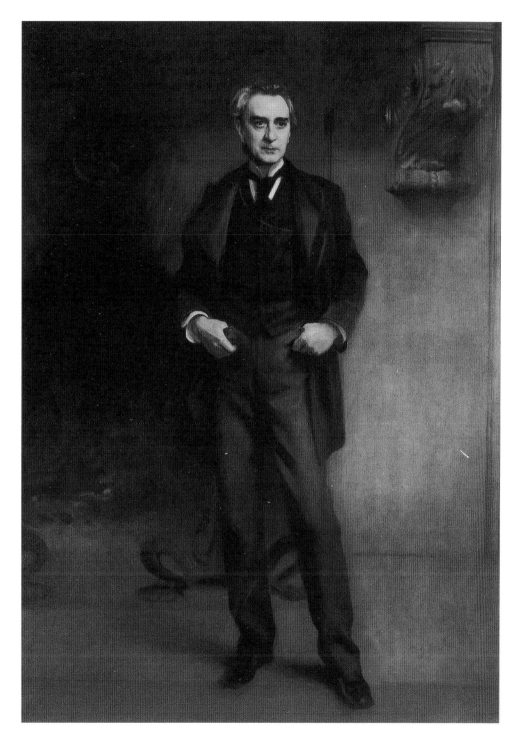

30. *Ada Rehan*

1894–5

Oil on canvas, 2362 x 1273mm
Inscribed, lower left: *John S. Sargent*
The Metropolitan Museum of Art, New York, USA

Born Delia Crehan in Limerick, Ireland, Ada Rehan
(1860–1916) moved to America at a young age, where she
followed her sisters on to the stage, appearing first, aged
sixteen, in Mrs John Drew's company at the Arch Street
Theatre, Philadelphia. A misprint on a theatre bill rendered
her name Ada C. Rehan, and the name stuck. She came
into her own in 1879 when she joined Augustin Daly's
theatre company, playing in Shakespeare's comedies and in
contemporary plays on both sides of the Atlantic. On Daly's
death in 1899 her career faltered and never revived. In his
portrait, Sargent plays up to the actress's imposing stage
presence, though she is not in character. She is dressed in a
sumptuous off-the-shoulder gown of ivory satin and holds
a large fan of ostrich feathers. The background tapestry of
horsemen, in the manner of Rubens, plays up the theatrical
mood, complemented by an Aubusson carpet. The artist had
originally planned a Persian carpet for the background, but
it dominated the picture. Progress was not easy. Rehan was
involved in rehearsals for *Twelfth Night*, and Sargent was busy
with portrait commissions and his Boston Library murals.
When Rehan wanted to withdraw from the commission due
to overwork, Sargent made a case for persisting, saying that he
achieved some of his best results with just a few sittings and
that some found the process restful. He carried his point. The
artist sent the finished picture to the 1895 summer exhibition
of the New Gallery, London, where it was warmly received.

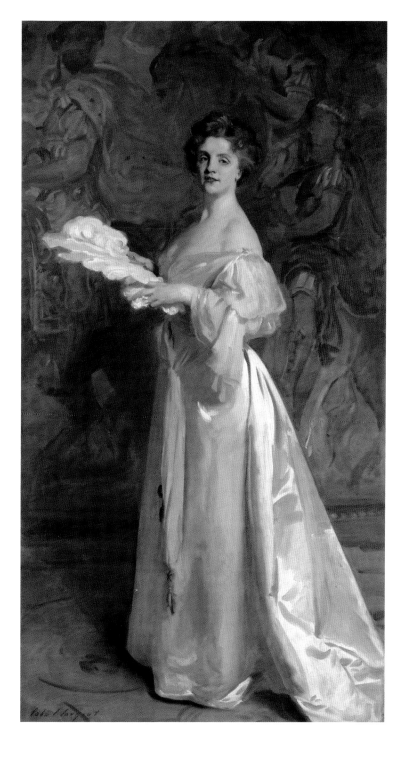

31. *Charles Martin Loeffler*
1903

Oil on canvas, 875 x 620mm
Inscribed, across top: *to Mrs Gardner con buone
feste/from her friend John S. Sargent*
Isabella Stewart Gardner Museum, Boston, Massachusetts, USA

The Alsace-born Loeffler (1861–1935) was an outstanding
violinist and composer whose work is being appreciated again
after a period of neglect. Trained in Paris, Loeffler moved
to Boston in 1882 to become Assistant Concertmaster at
the Boston Symphony Orchestra. From 1885 he served as
joint first violinist with Franz Kneisel, retiring in 1903 to
concentrate on composition. Like Sargent, Loeffler was a
close friend of Isabella Stewart Gardner, who admired his
work and invited him to play at her celebrated concerts.
Artist and sitter had first met in Boston in 1887. Sargent
was present at a Boston Symphony Orchestra performance
with Loeffler as the soloist. Meeting Sargent afterwards,
Loeffler found him charming and encouraging; later admiring
his erudite musicianship. The portrait was painted in Mrs
Gardner's Boston home, now the museum named for her,
on 10 April 1903, in a single sitting of less than four hours.
Loeffler was rehearsing his *Poème païen* for its first performance
at a birthday concert for Mrs Gardner; Sargent's portrait,
too, was a birthday gift. The head in profile emerges from a
shadowed background luminous with light as Loeffler, self-
absorbed, gazes into space. He grasps his violin with his left
hand while the other droops downward out of the picture
space. Here is the sensitive and creative musician immersed
in thought, with a score perhaps running through his mind.
Loeffler was drawn by Sargent in 1917, and this, together
with a group of the artist's watercolours, was bequeathed
to the Museum of Fine Arts, Boston, by Loeffler's widow.

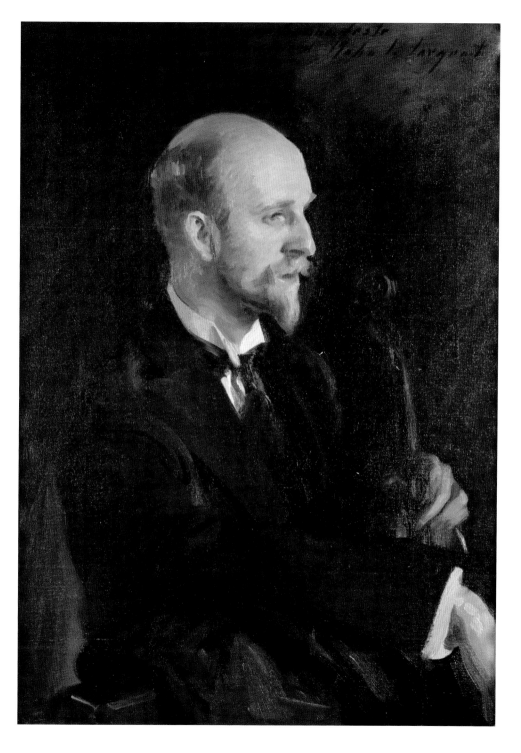

32. *An Artist in His Studio*
*c.*1904

Oil on canvas, 562 x 721mm
Inscribed, upper right: *John S. Sargent*
Museum of Fine Arts, Boston, Massachusetts, USA

Sargent first met the Italian painter Ambrogio Raffele
(1845–1928) at Purtud in the Val d'Aosta, Italy, in summer
1903, and this picture was either painted then or the following
year. Raffele was one of a group of north Italian landscape
painters with whom Sargent fraternised at Purtud; there was
a strong affection between the two men. Born in Vigevano in
northern Italy, Raffele enjoyed a long career as a landscapist
and figurative artist, his vigorous, naturalistic style akin to
Sargent's. With his long beard and domed forehead he was
often requisitioned as a model, featuring in a number of
Sargent's outdoor studies. In the present picture, he is depicted
in the cramped conditions of his Purtud hotel room with a
large landscape of trees and cattle straddling the washstand
and bed. Sargent brilliantly hits off the preoccupied figure in
crumpled suit and clumsy boots, sitting sideways in his chair
and squashed into one corner of the room. Paradoxically
the *plein-air* artist is not painting from nature out of doors
but constructing a painting from preliminary studies in his
makeshift studio. Was this also Sargent's preferred method
for his more finished landscapes and figure scenes? The
picture shows not only a studio but also a bedroom. The
sensuous textures of bedding, nightshirt and Panama hat are
conjured up in dazzling whites, with dashes of blue, which
strike a different note to the workday artist. Here, combined
in a single seemingly spontaneous sketch, radiant with
reflected sunlight, is the public artist and the private man.

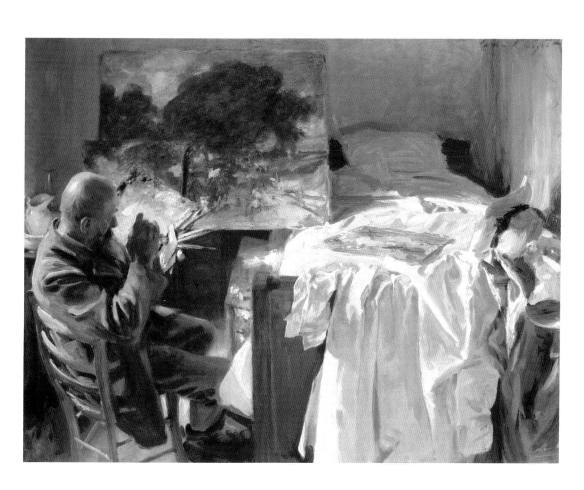

33. Sketching on the Giudecca, Venice (Wilfrid and Jane de Glehn)

*c.*1904

Watercolour on paper, over preliminary pencil, 355 x 508mm
Private Collection, on extended loan to the
National Museum of Wales, Cardiff, UK

The artists Wilfrid and Jane de Glehn are seen in a gondola
on the Giudecca canal in Venice, facing the Zattere. The
prow of the artist's gondola juts in from the left, the unseen
third in this triumvirate of artists. Both gondolas are attached
to one of two mooring ropes that run from the bow of the
sailing ship behind. The dramatic sweep of the ropes ties the
composition together and accentuates its depth. Wilfrid de
Glehn (1870–1951) is squatting on the side of the gondola,
under a canopy with a sketchpad in front of him, while Jane de
Glehn (1873–1961), seen from the back in white dress and hat,
watches her husband at work. The beautifully observed motif
of a devoted couple is set against a suffused soft-focus view of
shipping in muted ultramarines and siennas, freely brushed in
to describe the distilled Venetian light. Wilfrid and Jane were
on honeymoon in Venice. Both distinguished artists, they were
regular companions of Sargent over the following decade,
often travelling to Italy and Spain with him. They feature as
models in many of Sargent's pictures (see no. 36), the beautiful
Jane, in particular, posing for Sargent's decorative figure
compositions. Born Jane Erin Emmet, she was a member
of a family of artistically talented sisters brought up in New
Rochelle, New York, and distantly related to the writer Henry
James (no. 26). Her letters to her family in America (Archives
of American Art, Smithsonian Institution, Washington,
DC) are an invaluable biographical source for Sargent.

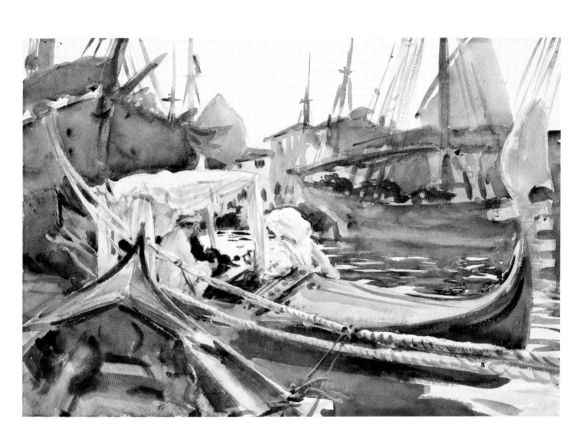

34. Group with Parasols
*c.*1904–5

Oil on canvas, 553 x 708mm
Inscribed, lower right: *to my friend Ginx / John S. Sargent*
Private Collection

This study shows four of the artist's friends abandoned in
sleep in an Alpine meadow, so intermingled with each other
and the landscape that it is difficult to differentiate them.
The rounded curves of the female bodies and the sunshades
are counterpointed by the angular arms and legs of the
men. On the left are Dos Palmer and Lillian Mellor; to the
right Leonard ('Ginx') Harrison, with his head in Lillian's
lap, and his brother Lawrence ('Peter') Harrison. While the
sensuality of the scene shows scant regard for contemporary
propriety, more shocking might have been the fact that
Palmer, the daughter of an American railroad tycoon, was
Peter Harrison's long-term mistress. She and the Harrisons
were part of the artist's Chelsea circle in London. Peter, a
talented painter, often appeared in Sargent's Alpine pictures
with his knees up, as here; his brother Ginx worked in the
family stock-broking business. Lillian Mellor features only
this once in the Sargent story. The picture was probably
painted in the environs of Giomein, Italy. In it the artist's
modernist credentials underpin how he crops and foreshortens
the composition and flattens the space. Figures and landscape
have equal weight in Sargent's electrifying performance, a
sensation at London's New English Art Club in 1906. For
one reviewer (*Pall Mall Gazette*, 25 June 1906) the painting
dominated the exhibition: 'The heat of the day is expressed
in the very shadows, and the attitude of every limb speaks
of the sensuous enjoyment of complete rest in the open
air. Here again we are confronted by complete mastery.'

35. *Alberto Falchetti*
*c.*1905

Oil on canvas, 749 x 546mm
Inscribed, across top: *to my friend Bertino Falchetti John S. Sargent*
Inscribed, on reverse, in another hand:
*John S. Sargent – (Londra)/ritrato del pittore/Alberto Falchetti/
Al Giomein (Valtournenche)*
Collection of Mr and Mrs Richard M. Thune

Alberto Falchetti (1878–1956) was one of a group of north
Italian painters with whom Sargent formed strong bonds of
friendship when he went to paint down in the Val d'Aosta
(1903–8) in the Italian Alps. The group, which included
Ambrogio Raffele (no. 32), Carlo Pollonera and Carlo Stratta,
also followed Sargent to the Simplon Pass (1909–12) in
Switzerland. If the inscription on the reverse is correct, the
portrait of Falchetti would have been painted at Giomein on
the Italian side of Monte Cervino (the Matterhorn). Sargent
was there with friends in the summer of 1905, staying in
the Hôtel Mont Cervin. The handsome, saturnine, heavily
bearded Falchetti, dressed in black, looks out with a decidedly
theatrical air. His head is turned and cocked to one side, his
eyes glint and his flesh tones read warmly in the subdued
light. He is standing in the doorway of a room: within the
interior behind him is a curtained window and furniture
scattered with books and objects, including a pot with
paintbrushes and a bowl possibly with pigment. The young
Falchetti exudes self-confidence and the stylish persona of
an artist – although Sargent could find Falchetti's pretensions
irritating, once deeming him a bore. Falchetti was born at
Caluso, near Turin, and became a gifted landscape painter
in a modernist style. The imagery of his mountain subjects,
often strikingly similar to Sargent's, indicates they must on
occasion have painted side by side. *A Glacier* by Falchetti
was included in the Sargent sale of 1925 at Christie's.

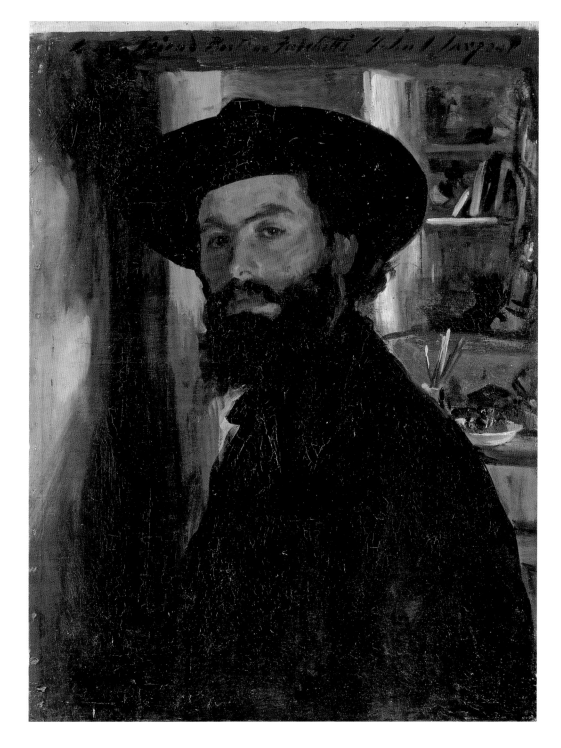

36. ## *The Fountain, Villa Torlonia, Frascati, Italy (Wilfrid and Jane de Glehn)*
1907

Oil on canvas, 714 x 565mm
Inscribed, lower left: *John S. Sargent*
The Art Institute of Chicago, Illinois, USA

The artist Jane de Glehn is shown sketching beside the great
pool of Villa Torlonia in Frascati outside Rome, watched by
her husband and fellow artist Wilfrid de Glehn. The quatrefoil-
shaped pool, enclosed within a magnificent balustrade, lies at
the top of a spectacular cascade that falls down the hillside
to the Renaissance villa belonging to the Torlonia family.
Sargent was fascinated by the pool, recording it in some
ten oil paintings and watercolours. *The Fountain* juxtaposes
Sargent's painting companions in white with the shoot of
water, the weathered stone of the balustrade and a dense green
background of ilex. Jane de Glehn is alert and concentrated,
her feet resting on a fold-up stool. Later describing her own
expression as worried, Sargent countered that it was a look
every painter should adopt who wasn't stupid. Wilfrid, on the
other hand, leans back indolently, his thumbs caught in his belt.
According to Jane, Sargent made him assume a contemptuous
expression to avoid the picture resembling a sunlit idyll
aboard a P&O liner. The figure of Wilfrid helps to balance
the design and introduces both a narrative element and a
mood of intimacy. Jane had married Wilfrid von Glehn (later
becoming 'de Glehn') in London in 1903. She was known for
her portrait drawings in sanguine chalk and her oil landscapes.
Wilfrid came from Estonian and French Protestant parentage.
He studied in Paris under Jean-Paul Laurens; in London under
George Percy Jacomb-Hood. A prolific portraitist and subject
painter, Wilfrid worked in a style that reflected that of Sargent,
whom he revered; the two artists often painted side by side.

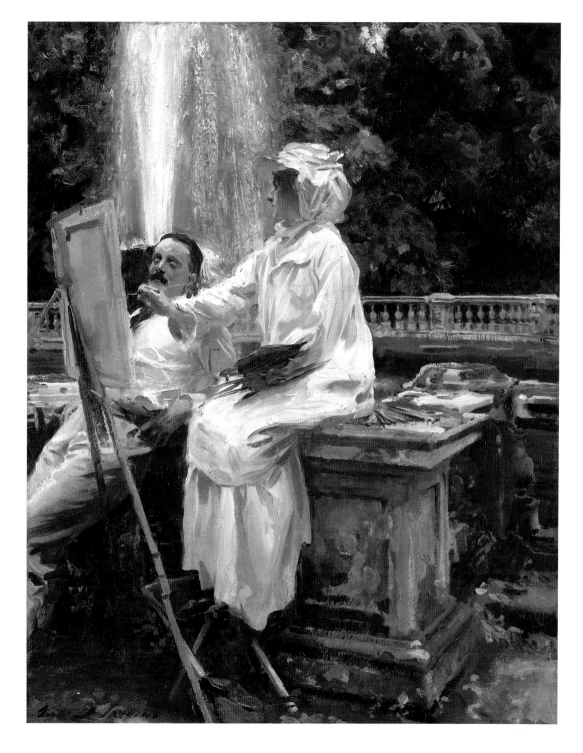

Chronology

1856 Born 12 January in Florence, Italy, the eldest surviving child of Dr Fitzwilliam Sargent (1820–89), an American surgeon, and Mary Newbold Singer (1826–1906), a prosperous merchant's daughter, who had left Philadelphia together on a European tour soon after the death of their first daughter at the age of two. Sargent spends his childhood touring Europe, mainly Italy, France, Switzerland and Germany, with his family, and receives very minimal formal schooling, in part due to his expatriate parents' nomadic lifestyle. His mother maintains that 'Europe itself [was] sufficient education for her son.' [1]

1857 Sargent's sister Emily is born in Rome on 29 January. She is weak and unwell as a child, in contrast to her energetic, animated brother, and is confined to the house for much of the time. The two children, only a year apart in age, later learn to read together (in French at first) and become very close.

1859 Sargent's maternal grandmother, Mary Singer, who travelled to Europe with her daughter and son-in-law, dies in Rome, Italy, on 12 November.

1860 Shows early promise in the fields of art and music, encouraged by his artistic mother. When almost five years old, Sargent produces his earliest surviving sketch: a portrait of his father, which Fitzwilliam encloses in his weekly letter to his own father on 18 December, noting:

'While I was engaged in writing to you, John has had the impertinence to take my portrait, which I enclose, thinking you will prize it.' [2]

1861 Sargent's sister Mary Winthrop (Minnie) is born in Nice, France, on 1 February.

1865 Minnie dies in Pau, France, on 18 April.

1866 The Sargents befriend the Pagets, whose daughter Violet later becomes better known as the writer Vernon Lee. Violet and Sargent affectionately refer to each other as 'my twin', and she becomes a close friend of his and Emily's in Nice. [3]

1867 Sargent's brother, Fitzwilliam Winthrop, is born in Nice on 7 March.

1868 The Sargents settle in Rome for the winter, where Mary entertains artists, writers and distinguished Americans. She shows Sargent's sketches to artists including Carl Welsch, a German–American painter then living in Rome, who thinks that they show promise. Sargent's parents decide that he should apply himself exclusively to the development of his artistic talent. [4]

1869 Fitzwilliam Winthrop Sargent dies.

1870 Another sister, Violet (named after her godmother, Violet Paget), is born in Florence on 9 February.

1873 After a spell in Dresden in the winter of 1871–2, the family returns to Florence, where

Sargent enrols in classes at the Accademia di Belle Arti. The Accademia closes soon afterwards (reopening in March 1874), and Sargent is left to teach himself at his studio on via Magenta. British and American expatriate painters, such as Edward Clifford (1844–1907), Charles Heath Wilson (1809–82), Edwin White (?1818–77), Frank Fowler (1852–1910) and Walter Launt Palmer (1854–1932), advised the Sargents on the next step for their son, and the family decides to move to Paris so that Sargent can continue his training there.

1874 The family arrives in Paris on 16 May, and Palmer recommends that Sargent study with Charles Auguste Émile Durand, known as Carolus-Duran. Sargent is accepted on the spot, with his new tutor finding 'much to be unlearned … but promise above the ordinary',[5] and remains with Carolus-Duran, first as a student and then as an assistant, until 1878. His mentor exerts a profound influence on his life and career. Once Sargent is enrolled at the atelier, the family is obliged to settle in Paris for the foreseeable future, and their last remaining American ties are broken with the death of Sargent's grandfather, Winthrop Sargent (1792–1874).

Passes the rigorous concours de places at the first attempt to gain admission to the prestigious and traditional École nationale supérieure des beaux-arts, placed thirty-seventh out of 162 entrants. Sargent's talents inspire awe in his contemporaries, with one fellow student, Julian Alden Weir, describing him in a letter to his mother as 'one of the most talented fellows I have ever come across'. [6]

1875 Passes the concours for the second time, in March, this time placed thirty-ninth, and matriculates at the École.

1876 Possibly meets Monet and Paul Helleu in April, although the dates of both meetings are unconfirmed. Makes first trip to the United States at the age of twenty-one with his mother and sister Emily in May, spending four months touring the East Coast and Canada, and meeting American relatives for the first time.

1877 In March, passes the concours and matriculates at the École for the third time, in second place – the highest placing yet for a student of Carolus-Duran's, and for an American. Fitzwilliam Sargent writes to his brother on 3 April that '[John] seems to be doing very satisfactorily – which is a great comfort to us – and to have chosen his vocation.'[7] Sargent's Portrait of Miss Watts, the first of his works to be submitted, is accepted into the Salon (the official art exhibition of the Académie des beaux-arts) and exhibited there in May. Carolus-Duran selects Sargent and his fellow student J. Carroll Beckwith to assist him with a ceiling decoration for the Palais du Luxembourg. Elected to the jury of the new Association of American Artists, founded in June and later called the Society of American Artists.

1878 The first Society of American Artists exhibition takes place at the Kurtz Gallery, New York, in March; Sargent exhibits Fishing for Oysters at Cancale there. Exhibits En route pour la pêche at the Salon in May; Carolus-Duran's ceiling mural, produced with assistance from Sargent and Beckwith, is also shown. Carolus-Duran agrees to sit to Sargent for his portrait.

1879 Sargent's portrait of Carolus-Duran (no. 1) is completed in May to critical acclaim. It is exhibited at the Salon and is awarded an honourable mention, which exempts Sargent from jury scrutiny the following year. Sargent also exhibits Dans les oliviers à Capri at the Salon. Fitzwilliam Sargent writes to his brother, months after seeing Carolus-Duran at the Salon, that 'the proof of the pudding is in the eating, so … one of the best evidences of a portrait's success is the receiving by the artist of commissions to execute others. And John received six such evidences from French people.'[8] One of these is from Édouard Pailleron, who commissions Sargent to paint portraits of his family, including Madame Édouard Pailleron, at Ronjoux.

1880 *Carolus-Duran* is exhibited at the Society of American Artists, New York, in March–April. Exhibits *Madame Édouard Pailleron* (no. 4) and *Fumée d'ambre gris* at the Salon in May. Later that year, Sargent travels to Haarlem, Holland, with the American artists Ralph Wormeley Curtis (1854–1922) and Francis Brooks Chadwick (1850–1942), and then to Venice via Aix-les-Bains. Sets up a studio in Venice, and his time in the city overlaps with Whistler's (although there is no record of the two men meeting).

1881 Leaves Venice and returns to France. Travels to London in June, where he paints Vernon Lee (no. 8). Returns to Paris, painting a portrait of Dr Pozzi and working on *El Jaleo*.

1882 *El Jaleo* and *Lady with the Rose* (a portrait of Sargent's friend Louise Burckhardt, originally shown as *Portrait du Mlle* ★★★ in the Salon custom) are exhibited at the Salon, and *Dr Pozzi at Home* (no. 7) at the Royal Academy of Arts, London. *El Jaleo* is also shown at the Schwab Gallery, New York, and in Boston.

1883 Visits his family in Nice, then returns to Paris to work on a portrait of Madame Pierre Gautreau (later known as *Madame X*; fig. 2) and *Mrs Henry White*. Spends August and September in Paramé, Brittany, painting *Madame X* at Madame Gautreau's country house. Describes his sitter in a letter to Vernon Lee as having 'the most beautiful lines', but sittings are trying, and the pose they eventually settle on is a daring one. [9]

1884 Commissioned to paint *The Misses Vickers* in Sheffield. Arrives in London on 27 March and is accompanied the next day by Henry James to an exhibition of work by Sir Joshua Reynolds (1723–92) at the Grosvenor Gallery in Bond Street, and to the studios of British artists including Frederic Leighton (1830–96) and John Everett Millais (1829–96). Returns to Paris, where *Madame X* is exhibited at the Salon in May to a disastrous reception, with the sitter and her portrait roundly denounced by the press and public, although Sargent tells Vernon Lee that he is 'prouder of it than the Jaleo'. [10] Leaves Paris for England again, where he paints members of the Vickers family in Sheffield and Robert Louis Stevenson in Bournemouth before returning to Paris in December.

1885 *The Misses Vickers* and *Mrs Albert Vickers* are exhibited at the Salon. Almost certainly visits Monet at Giverny in the summer and paints *Claude Monet, Painting, by the Edge of a Wood* (no. 12). Returns to Bournemouth in May, where he paints Robert Louis Stevenson and his wife (no. 18). After a swimming accident in August during a boating trip on the Thames with Edwin Austin Abbey (1852–1911), Abbey takes him to stay with Frank Millet at Farnham House in Broadway, Worcestershire. Here, Sargent paints landscapes and begins work on *Carnation, Lily, Lily, Rose* (no. 15) in the garden of Farnham House.

1886 Spends the beginning of the year in London and decides by March to move there permanently. Packs up his Paris studio and moves in June. Visits Bayreuth for the Wagner festival in August and works on *Carnation, Lily, Lily, Rose* in London and Broadway in the autumn. Introduced by Henry James to Isabella Stewart Gardner, a Boston-based art collector and patron, who becomes a close friend and sits to Sargent for her portrait.

1887 *Carnation, Lily, Lily, Rose* is shown at the Royal Academy, receives an extremely positive response from the public and critics alike and is purchased by the Chantrey Bequest for £700. Leases a studio in Tite Street, Chelsea. Commissioned to paint a portrait of Mrs Henry G. Marquand in Boston and remains in the US until May 1888. While there, paints portraits including *Mrs Charles E. Inches* and *Mrs Edward Darley Boit*.

1888 Completes portrait of Mrs Gardner in January. First solo exhibition opens at Boston's St Botolph Club on 28 January and is a huge success, with more than 1,300 people flocking

to the twenty-picture show; works exhibited include *El Jaleo* and *The Daughters of Edward Darley Boit*. On returning to England in May, moves with his family to Calcot Mill, on the banks of the River Kennet, near Reading in Berkshire. Visitors over the summer include Vernon Lee and Monet. Attends the first night of *Macbeth* in December, starring Henry Irving (1838–1905) and Ellen Terry.

1889 Paints *Ellen Terry as Lady Macbeth* (no. 23). Exhibits six paintings at the Exposition Universelle (American section) in Paris, where he is awarded a grand prix and created chevalier de la Légion d'honneur. Paints several studies of Javanese dancers. His father, Fitzwilliam Sargent, dies in Bournemouth on 25 April. Sargent sails to New York with his younger sister Violet on 4 December.

1890 Sees La Carmencita dance in New York in February and begins painting her portrait in March. When offered the equivalent of £600 for *La Carmencita* (no. 28) in New York, Sargent refuses, saying that the jewellery his sitter wears means that the portrait has cost him more than that amount to paint. Exhibits at the St Botolph Club in Boston and the Society of American Artists in New York, and is informally commissioned by the architect Charles McKim (1847–1909) to paint mural decorations for the Boston Public Library (fig. 4). Travels to Egypt with his mother and sisters to do research for the murals.

1891 Rents a studio in Cairo and travels to Luxor, then to Greece and Turkey. Attends his sister Violet's wedding to (Louis) Francis Ormond in Paris in July. Returns to England, where he shares a large studio, Morgan Hall in Fairford, Gloucestershire, with Edwin Austin Abbey.

1892 Spends the first half of the year working on portraits and murals in Fairford, before travelling to Spain to visit his mother and sister Violet in August. *La Carmencita* is purchased by the Musée du Luxembourg, Paris.

1893 *Mrs Hugh Hammersley*, exhibited at the New Gallery, London, and *Lady Agnew of Lochnaw* (fig. 3), at the Royal Academy, are both praised by critics, helping to establish Sargent's reputation in England.

1894 Elected an associate of the Royal Academy of Arts, London. Paints a portrait of Coventry Patmore (1823–96), an English poet, whom he also persuades to pose as Ezekiel as part of his frieze of the prophets at the Boston Public Library.

1895 Travels to Boston to oversee the installation of part of the Public Library murals, which are unveiled at a reception given by Charles McKim on 25 April. *Coventry Patmore* and *W. Graham Robertson* (no. 25) are exhibited at the Royal Academy Gives up his share in Morgan Hall and leases two studios in Fulham Road, London.

1896 Commissioned to paint *Henry G. Marquand* for The Metropolitan Museum of Art, New York. Paints *Mrs Carl Meyer and Her Children* in October. Reviewing the latter for *Harper's Weekly* in New York, Henry James writes that Sargent 'expresses himself as no one else scarce begins to do in the language of the art he practices'.[11]

1897 Spends January and February on mural research in Palermo, Sicily, then returns to London in March, where he is elected a full member of the Royal Academy of Arts, London.

1898 Paints *Asher Wertheimer*, then travels to Venice, where he paints *An Interior in Venice* and travels in Italy throughout May. On returning to London in June, portrait sittings take up much of his time; Sargent increases his fee to 1,000 guineas for a full-length portrait.

1900 Enlarges his Tite Street studio by leasing the house next door and knocking down the dividing wall. In the autumn, travels in Switzerland and Italy.

1901 Declines a commission to paint the coronation of Edward VII, which is instead undertaken by Edwin Austin Abbey.

1903 Paints President Theodore Roosevelt (1858–1919) in February, with Roosevelt writing to him personally: 'It seems eminently fitting that an American President should have you paint his picture. I cordially thank you.'[12] Paints portraits in the Gothic Room at Mrs Gardner's palazzo, Fenway Court, Boston. First London solo show is held at the Carfax Gallery. A monograph on Sargent by the poet, essayist and journalist Alice Meynell (1847–1922) is published in December in London.[13]

1904 From 1904 onwards, exhibits subject pictures at the New English Art Club and watercolours at the summer and winter exhibitions of the Royal Watercolour Society, London.

1905 Begins to complain more emphatically about the drudgery of painting commissioned portraits, saying to the French painter Jacques-Émile Blanche (1861–1942): 'What a nuisance having to entertain the sitter and to look happy when one feels wretched.'[14] *An Artist in His Studio* (no. 32) is bought by the Museum of Fine Arts, Boston, for $1,000. Travels to Syria and Palestine in November for more mural research and paints more than a dozen oils and more than forty watercolours there.

1906 His mother, Mary Sargent, dies in London on 21 January; Sargent returns from his travels in the Middle East for the funeral, arriving on 2 February.

1907 Sargent declares that he is giving up portraiture, at the age of fifty-one. Recommended for a knighthood by Edward VII, but responds that his American citizenship makes him ineligible. Travels to Italy in August with Emily, Violet and her children, the artists Jane and Wilfrid de Glehn and Polly Barnard, daughter of the late painter Frederick Barnard (1846–96), and a model, with her sister Dorothy, for *Carnation, Lily, Lily, Rose.*

1909 Exhibits eighty-six watercolours with the wealthy Boston lawyer-turned-painter Edward Darley Boit (1842–?1916) at Knoedler's, New York, and the Brooklyn Museum buys eighty-three of them for $20,000. Travels to Corfu with the de Glehns and Eliza Wedgwood, another of Sargent's regular travelling companions on his sketching expeditions, where he paints *In the Garden, Corfu.*

1910 Travels to Florence and stays at the Villa Torre Galli with Emily, the de Glehns, Sir William Blake Richmond and Lady Richmond, and paints a series of studies of the loggia. Continues to work on the Boston mural project.

1912 A second watercolour exhibition with Edward Darley Boit is held at Knoedler's, and the Museum of Fine Arts, Boston, purchases forty-five of the works.

1913 Paints Henry James (no. 26) to mark his seventieth birthday. Travels to Paris for the wedding of his niece Rose-Marie in August, then to Venice.

1914 A suffragette slashes Sargent's portrait of Henry James at the Royal Academy on 14 May. Travels to Austria with his British friends the Stokeses and is confined there after war is declared (on Germany on 4 August and on Austria–Hungary on 10 August), because the Stokeses are considered enemy aliens. Sargent's paintings and equipment are confiscated, but he finally acquires the passport he needs and returns to London at the end of November.

1916 Sails to Boston on 20 March for his first visit to the US in thirteen years and, at two years, what will be his longest. *Madame X* is offered for purchase to The Metropolitan Museum of Art, New York. Library installations begin, and Sargent agrees to do the decorations for the rotunda of the Museum of Fine Arts, Boston.

1918 His niece Rose-Marie is killed by a long-range German shell while attending a Good Friday service at St-Gervais-et-St-Protais Church, Paris. Sargent returns to England in

May, then leaves, as official war artist, for the Western Front on 2 July, with the British ex-surgeon, painter and draughtsman Henry Tonks (1862–1937). Paints *Gassed* after seeing soldiers blinded by mustard gas in Arras, France. In December, he declines the presidency of the Royal Academy of Arts, London.

1919 Travels to Boston, where he works on the decorations for the Museum of Fine Arts rotunda. *Gassed* is named picture of the year at the Royal Academy.

1920 Spends the first half of the year in Boston, before returning to England in July and beginning work on *General Officers of World War I.*

1921 Works on rotunda decorations and installations in Boston, then returns to England in October. Agrees to paint panels for the Harry Elkins Widener Memorial Library at Harvard University.

1922 Sails for Boston, where the Widener panels are installed in November. Returns to England in November.

1923 The Wertheimer portraits are installed at the National Gallery, London, in January, and Sargent works on panels for the Museum of Fine Arts, Boston, in his Fulham Road studio. Returns to Boston with Emily in October.

1924 A retrospective of Sargent's work is held at the Grand Central Art Galleries in New York, 23 February–22 March. Returns to England with Emily in July and continues his mural work.

1925 Completes the Boston murals in March and in April books tickets to travel there to supervise their installation. After a farewell dinner on 15 April, Sargent dies in his sleep at Tite Street. Buried at Brookwood Cemetery, Woking, Surrey, with a memorial service at Westminster Abbey on 24 April. Sargent's first memorial exhibition opens at the Museum of Fine Arts, Boston, on 3 November.

––––––––––

Key reference: Richard Ormond and Elaine Kilmurray (eds), *John Singer Sargent* (Tate Publishing, London, 1998)

1 Stanley Olson, *John Singer Sargent: His Portrait* (Macmillan, London, 1986), p.18.
2 Ibid., p.9. The drawing is at the Sargent-Murray-Gilman-Hough House Association, Gloucester, Massachusetts.
3 Ibid, p.14.
4 Charles Merrill Mount, *John Singer Sargent* (The Cresset Press, London, 1957), pp.19–20.
5 Ibid, p.28.
6 Julian Alden Weir to his mother, Paris, October 4, 1874, quoted in Weinberg, ibid., p.207.
7 Ibid., p.57.
8 Ibid., p.75.
9 Ibid., p.103.
10 Ibid, p.108.
11 Ibid, p.207.
12 Mount, op. cit., p.199.
13 Alice Meynell, *The Work of John S. Sargent, R.A.* (W. Heinemann, London, 1903).
14 Jacques-Émile Blanche, *Portraits of a Lifetime*, trans. & ed. Walter Clement (J.M. Dent & Sons Ltd, London, 1937), p.158.

Picture Credits

The National Portrait Gallery would like to thank the copyright holders for granting permission to reproduce works illustrated in this book. Every effort has been made to contact the holders of copyright material, and any omissions will be corrected in future editions if the publisher is notified in writing. Dimensions of works are given height x width (mm), where available.

1. *Carolus-Duran*, 1879. Oil on canvas, 1168 x 960mm. Sterling and Francine Clark Art Institute, Williamstown, Massachusetts, USA, 1955.14. Photo © Sterling and Francine Clark Art Institute, Williamstown, Massachusetts, USA (photo by Michael Agee).

2. *Ramón Subercaseaux in a Gondola*, *c*.1880. Oil on canvas mounted on panel, 371 x 549mm. Collection of the Dixon Gallery and Gardens, Memphis, Tennessee; Gift of Cornelia Ritchie, 1996.2.13.

3. *Édouard Pailleron*, 1879. Oil on canvas, 1385 x 960mm. Paris, Musée d'Orsay. Photo: © RMN – Grand Palais (musée d'Orsay)/Hervé Lewandowski.

4. *Madame Édouard Pailleron*, 1879. Oil on canvas, 2070 x 1007mm. Corcoran Gallery of Art, Washington, DC. Museum purchase and gifts of Katherine McCook Knox, John A. Nevius and Mr and Mrs Lansdell K. Christie.

5. *Portraits de M.E.P. … et de Mlle L.P. (Portraits of Édouard and Marie-Louise Pailleron)*, 1881. Oil on canvas, 1524 x 1753mm. Des Moines Art Center Permanent Collections. Purchased with funds from the Edith M. Usry Bequest, in memory of her parents, Mr and Mrs George Franklin Usry, the Dr Mrs Peder T. Madsen

Fund, and the Anna K. Meredith Endowment Fund, 1976.61.

6. *Madame Ramón Subercaseaux*, 1880. Oil on canvas, 1651 x 1099mm. Private Collection.

7. *Dr Pozzi at Home*, 1881. Oil on canvas, 2016 x 1022mm. The Armand Hammer Collection. Gift of the Armand Hammer Foundation, Hammer Museum, Los Angeles.

8. *Vernon Lee*, 1881. Oil on canvas, 537 x 432mm. Tate: Bequeathed by Miss Vernon Lee through Miss Cooper Willis, 1935. Photo: © Tate, London, 2015.

9. *Madame Allouard-Jouan*, *c*.1882. Oil on canvas, 750 x 558mm. Paris, Petit Palais, Musée des Beaux-Arts de la Ville de Paris. Collection Dutuit. Photo: © RMN – Grand Palais/Agence Bulloz.

10. *Judith Gautier*, *c*.1883. Oil on panel, 991 x 622mm. Detroit Institute of Arts, USA/Gift of Mr and Mrs Ernest Kanzler. Photo: The Bridgeman Art Library.

11. *Auguste Rodin*, 1884. Oil on canvas, 725 x 525mm. Musée Rodin, Paris.

12. *Claude Monet, Painting, by the Edge of a Wood*, probably 1885. Oil on canvas, 540 x 648mm. Tate: Presented by Miss Emily Sargent and Mrs Ormond through the Art Fund, 1925. Photo: © Tate, London, 2015.

13. *Fête familiale (The Birthday Party)*, *c*.1885(?). Oil on canvas, 609 x 737mm. Minneapolis Institute of Arts, MN, USA/The Ethel Morrison Van Derlip Fund and the John R. Van Derlip Fund.

14. *Le Verre de Porto (A Dinner Table at Night)*, 1884. Oil on canvas, 514 x 667mm. The Fine Arts Museums of San Francisco. Gift of the Atholl McBean Foundation, 73.12. Photo: Fine Arts Museums of San Francisco.

15. *Carnation, Lily, Lily, Rose*, 1885–6. Oil on canvas, 1740 x 1537mm. Tate: Presented by the Trustees of the Chantrey Bequest, 1887. Photo: © Tate, London, 2015.

16. *Mrs Frank Millet*, probably 1885–6. Oil on canvas, 883 x 673mm. Private Collection.

17. *Edmund Gosse*, 1886. Oil on canvas, 611 x 508mm. Leeds University Library, Brotherton Collection, Bequest of Dr Philip Gosse, 1959. Photo: University of Leeds Art Collection.

18. *Robert Louis Stevenson and His Wife*, 1885. Oil on canvas, 514 x 616mm. Crystal Bridges Museum of American Art, Bentonville, Arkansas. Photo: © Crystal Bridges Museum of American Art, Bentonville, Arkansas. Photography by Dwight Primiano.

19. *Self-portrait*, 1886. Oil on canvas, 345 x 297mm. Aberdeen Art Gallery and Museums Collections.

20. *An Out-of-Doors Study*, 1889. Oil on canvas, 659 x 807mm. Brooklyn Museum, Museum Collection Fund, 20.640.

21. *Portrait of George Henschel*, 1889. Oil on canvas, 635 x 533mm. Crystal Bridges Museum of American Art, Bentonville, Arkansas. Photo © Crystal Bridges Museum of American Art, Bentonville, Arkansas. Photography by Dwight Primiano.

22. *Gabriel Fauré*, c.1889. Oil on canvas, 610 x 546mm. Collection Musée de la musique. Photography © Courtesy Collection Musée de la musique/Cliché Anglès.

23. *Ellen Terry as Lady Macbeth*, 1889. Oil on canvas, 2210 x 1143mm. Tate: Presented by Sir Joseph Duveen, 1906. Photo: © Tate, London, 2015.

24. *Mrs George Batten Singing*, 1897. Oil on canvas, 889 x 432mm. Lent by Glasgow Life (Glasgow Museums) on behalf of Glasgow City Council. Presented by the Trustees of the Hamilton Bequest, 1929.

25. *W. Graham Robertson*, 1894. Oil on canvas, 2305 x 1187mm. Tate: Presented by W. Graham Robertson, 1940. Photo: © Tate, London, 2015.

26. *Henry James*, 1913. Oil on canvas, 851 x 673mm. National Portrait Gallery, London (NPG 1767). Photo: © National Portrait Gallery, London.

27. *William Butler Yeats*, 1908. Charcoal on paper, 622 x 470mm. Private Collection.

28. *La Carmencita*, 1890. Oil on canvas, 2320 x 1420mm. Paris, Musée d'Orsay. Photo: © RMN – Grand Palais (musée d'Orsay)/Gérard Blot.

29. *Edwin Booth*, 1890. Oil on canvas, 2223 x 1568mm. Amon Carter Museum of American Art, Fort Worth, Texas 2013.7.

30. *Ada Rehan*, 1894–5. Oil on canvas, 2362 x 1273mm. Lent by The Metropolitan Museum of Art. Bequest of Catharine Lasell Whitin, in memory of Ada Rehan, 1940 (40.146).

31. *Charles Martin Loeffler*, 1903. Oil on canvas, 875 x 620mm. Isabella Stewart Gardner Museum, Boston. Photo © Isabella Stewart Gardner Museum, Boston, MA, USA/The Bridgeman Art Library.

32. *An Artist in His Studio (Ambrogio Raffele)*, c.1904. Oil on canvas, 562 x 721mm. Museum of Fine Arts, Boston. The Hayden Collection – Charles Henry Hayden Fund (05.56).

33. *Sketching on the Giudecca, Venice (Jane and Wilfrid de Glehn)*, c.1904. Watercolour on paper, over preliminary pencil, 355 x 508mm. Private Collection, on extended loan to the Amgueddfa Cymru-National Museum of Wales, Cardiff. Photo: © National Museum of Wales.

34. *Group with Parasols*, c.1904–5. Oil on canvas, 553 x 708mm. Private Collection.

35. *Alberto Falchetti*, c.1905. Oil on canvas, 749 x 546mm. Collection of Richard M. Thune.

36. *The Fountain, Villa Torlonia, Frascati, Italy*, 1907. Oil on canvas, 714 x 565mm. The Art Institute of Chicago, Friends of American Art Collection (1914.57).

Additional picture credits

Fig. 1: *Self-portrait*, 1906. Oil on canvas, 700 x 530mm. Galleria degli Uffizi, Colleziona degli Autoritratti, Florence.

Fig. 2: *Madame X (Madame Pierre Gautreau)*. Oil on canvas, 2086 x 1099mm. The Metropolitan Museum of Art 2014. Photo: © SCALA, Florence.

Fig. 3: *Lady Agnew of Lochnaw*, 1892. Oil on canvas, 1270 x 1010mm. National Galleries of Scotland, Scottish National Gallery.

Fig. 4: *Triumph of Religion mural*, Boston Public Library. Image courtesy Boston Public Library.

Fig. 5: *Isabella Stewart Gardner*, 1888. Oil on canvas, 1899 x 813mm. Isabella Stewart Gardner Museum, Boston. Photo: © Isabella Stewart Gardner Museum, Boston, MA, USA/The Bridgeman Art Library.

Fig. 6: *In the Generalife*, 1912. Watercolour, wax crayon and graphite on white wove paper, 375 x 454mm. Lent by The Metropolitan Museum of Art. Purchase: Joseph Pulitzer Bequest, 1915 (15.142.8).

Index